The World
of
William Hogarth

By the same author

The Pre-Raphaelite Tragedy
The Aesthetic Adventure
Victorian Olympus
Hogarth (Faber Gallery series)
A Concise History of English Painting
The Great Century of British Painting—Hogarth to Turner

The World
of
William Hogarth

William Gaunt

JONATHAN CAPE
THIRTY BEDFORD SQUARE LONDON

First published in 1978
© 1978 by William Gaunt

Jonathan Cape Ltd
30 Bedford Square, London WC1

British Library Cataloguing in Publication Data

Gaunt, William
The world of William Hogarth.
1. Hogarth, William
I. Title
760'.092'4 ND497.H7

ISBN 0-224-01445-5

Printed in Great Britain by The Anchor Press Ltd
and bound by Wm Brendon & Son Ltd
both of Tiptree, Essex

Contents

v

Illustrations

All works listed are by Hogarth except where otherwise stated

Preface

Art and social life in London in the first half of the eighteenth century with Hogarth as a key figure is the theme of this book. It aims to give a sketch of the character of the period – a pattern into which many threads are woven – some details of the various worlds of the satirists, dramatists, novelists and portrait painters with which Hogarth had points of contact, some particulars of individual contemporaries he knew and the nature of their efforts, some account of the causes he supported and those he fought. Fresh study has been given in recent years both to Hogarth and to the artists of his time in relation with whom both he and they can be seen in better perspective. The author has profited by the work of modern authorities to whom a bibliography is an expression of gratitude. His thanks are also due to the owners of works who have kindly allowed their reproduction.

W.G.

∽∾ I ∾∽

Metropolitan Background

London was William Hogarth's world. He was born in Bartholo-
mew Close, adjoining the ancient church of St Bartholomew the
Great, in 1697 when William III was king. He lived in the west-
central region of the city, with only brief excursions elsewhere,
through the reigns of Queen Anne, George I and George II. He
died at his house in Leicester Fields, by then already becoming
known as Leicester Square, in 1764, when the young George III
had been four years on the throne. Like another great character
of the age, Dr Samuel Johnson, he found in London 'all that life
can afford'.

It was a city of dramatic contrasts, offering ample material for
study to the philosopher, the man of letters and an artist with an
eye for its diversity—as well as ample scope for the reformer.
There was growing wealth. The finance of London backed ex-
peditions overseas that were building an empire of trade already
extending over the globe from Boston to Bombay. Coffee-houses,
clubs and taverns innumerable were media for the exchange of
news regarding events and profitable dealings abroad. But these
were the meeting-places also of the insular for whom London
itself was universe enough.

A suspicion of other countries, a contempt for foreigners in
general, were national traits on which visitors to the capital often
remarked. An exception was the attitude of those who completed
the education proper to a gentleman by going on the Grand Tour
through France to Italy. They came home with a reverence for art
and architecture seen abroad and correspondingly little respect for
the native product often enough. They included would-be 'con-
noisseurs', irritating to the untravelled with their 'talk of the

I

antique in a kind of cant in half or whole Italian'. They brought over 'wonderfull copies of bad originals, Ador'd for their names only'. Thus Hogarth described them with all the insularity of his nation and the personal bias that led him constantly to challenge foreign influence. Yet in one form or another, not only as regards the complex issues raised especially by painting, foreign influences could not well be kept out. The world of fashion accepted with complacence the appurtenances of luxurious living in which the European continent set the style. In some degree, the dress of the upper class conformed to the standards set by the French court. The mode insinuated itself into England, as elsewhere, irrespective of political enmities, declarations of war or prejudices otherwise aroused. A peculiar chivalry during conflict with France permitted the free passage across the Channel of dolls decked in the latest French finery. As well as supplying a continued source of ideas for the designer in London, dolls of this kind sometimes served as lay figures for the picture painter. Silks and satins, rich embroideries in gold and silver were alike the mark of the aristocracy and those of lesser degree who aspired to social distinction.

Members of the middle class grown prosperous took on an aristocratic air in butterfly brilliance of attire consonant with a handsome residence in town, though the middle class, as always, had its several strata. There were those of more modest ambition, with some return to the puritan attitudes of the past, who dressed and lived in the plainer manner appropriate to the shopkeeper and the craftsman. In his self-portraits Hogarth, sturdily bourgeois, never depicted himself wearing that emblem of eighteenth-century artificiality, the wig. We see him at his easel, close-cropped and with a cloth cap at an informal angle, dressed in simple homespun, as he roughs the outline of, appropriately, Thalia, muse of comic poetry, anciently reputed also (which may or may not have occurred to him) to be less given to ornament than her sister muses.

On either side of the mid-standpoint were the extremes of luxurious living and poverty and wild degradation. At the bottom of the social structure but formidable in number was the floating population of the outcast, the unemployed or unemployable, the malefactors and those so branded. Riches rubbed shoulders with misery. The sedan chair, exotic means of civic transport imported from Madrid, carried its refined burden of the fashionable through

the malodorous and undrained streets swarming with ragged beggars and brutal characters of the underworld. The night was full of sinister and doleful shadows, thieves on the prowl, the homeless sleeping rough under shop fronts or huddled round the bonfires that gleamed in the dark. An elegant company risked such a 'night encounter' as Hogarth painted should they not have a torch-bearing bodyguard.

There were contrasts in architecture. 'Resurgam', the word carved on the ancient stone that Sir Christopher Wren built into the fabric of St Paul's, could describe the handsome prospects of new brick and stone in what had been the timbered city, four-fifths of which was destroyed in the Great Fire of 1666. The order and symmetry that were to be so typical of the eighteenth century appeared in spacious squares and thoroughfares of regular height and proportion. Wren's fifty-one City churches when the century began were complete in their superb architectural symphony of steeples and spires as seen from the long curve of the Thames.

As if the wholesale reconstruction of the memorials of medieval piety was not enough, fifty new churches more were planned in the reign of Queen Anne, a time not notably pious. The High Church sentiment and policy of a Tory party briefly in office has been held to account for this surprisingly ambitious proposal, only in part realized during the early Georgian years. Fortunately for the look of London there were gifted architects to follow in the wake of Wren. Landmarks of architectural beauty, as familiar to the present day as they were to Hogarth and his contemporaries, include James Gibbs's St Mary-le-Strand, St Martin-in-the-Fields and the steeple with which he completed Wren's St Clement Danes. Nicholas Hawksmoor, long the associate of Wren but with his own originality of design, added the strange magnificence of St George's, Bloomsbury as it appears in the background of Hogarth's *Gin Lane*, as well as great churches in Spitalfields and Limehouse. These bear witness to an eastward expansion in the region populated by Huguenot weavers and to the increasing river traffic and its establishments alongshore. The new order of architecture mainly belonged to the fresh ground covered to the west, north and east of the City as anciently defined. The ground plan, outlined by the 'gates' that in name preserved the memory of the several entrances to the medieval walled city, outlasted the Fire.

The close-knit web of narrow streets, lanes and alleys confronted the planner with insoluble problems. Funds, organization and public interest were all lacking to give effect to a comprehensive and rational plan such as Sir Christopher Wren had proposed. Hogarth has his reminder to give of the decrepit byways that survived, huddling together tumbledown hovels, drinking dens and 'night-cellars' of ill repute. Very different was this murky London from the city of palaces that the visiting Venetian artist Canaletto invested with grandeur and a sparkling purity of atmosphere.

Even freedom had its contrasts. In free thought and expression of opinion London astonished a foreign observer such as Voltaire, accustomed in France to the tyranny of censorship and exiled to England by reason of the witty lampoons he directed against the French Regent and his court. The Hanoverians, George I and George II, were in no position to suppress whatever adverse comment might be directed against them. They were regarded critically or with indifference as aliens and in their small knowledge of the language and the people there was some indifference on their side also. Lord Hervey, an insular Saint-Simon in malice, viewed the household of George II with the irreverence that adds spice to his *Memoirs*. If the king was angry at the unflattering picture of his guardsmen that Hogarth painted in the famous *March to Finchley*, that was as far as the matter went. Nor could he demand dire penalties because, instead of dedicating the engraving from the picture to him, the artist chose to dedicate it to the King of Prussia.

The Whig party that guaranteed the Hanoverian succession was secure enough in power under the guidance of Sir Robert Walpole during the first half of the century to be tolerant. Walpole's favourite maxim on non-interference, *quieta non movere*, has an easy-going suggestion. It implied that as well as keeping out of war, institutions and trading operations were best let alone. This appearance of indulgence had its darker aspect. There were institutions that needed changing, among them the law itself and the punishments it prescribed. Even the most venial offence could lead to transportation or execution. Freedom became an empty word, meaning no more than leave granted to quite worthy, if economically not very competent persons, to sink into the social depths. Worse than the fact that no hand might be raised to help

them was the liability to imprisonment that in all innocence they might incur.

Frightful and absurd at the same time was the debtors' prison, a purgatory between liberty and confinement, futile in so far as it excluded any means of discharging a debt. It would be hard to imagine a system as effectively designed to discourage effort or suppress hope, or administered by overseers of a more corrupt and even savage kind than those who flourished in the years of Hogarth's youth. Yet it was in a notorious place of the kind that he must have gained a vivid first impression of a despairing and desperate side of his London world—the Fleet prison.

2

Glimpse into the Depths

To these grim lodgings, despite the best of intentions, the artist's father, Richard Hogarth, found himself consigned, together with his family when his son was about ten. The image of Richard Hogarth remains as one of those mildly cultivated and unworldly beings who have not seldom fathered great men. Such a man in a future age was the father of Charles Dickens who likewise spent some time in a debtors' prison, the Marshalsea, accompanied by his family. The comparison recalls how long such places continued to exist, as well as the use of the experience a great artist was able to make, Hogarth in *A Rake's Progress* and Dickens in *The Pickwick Papers*. With a modest store of classical scholarship, Richard Hogarth had left his native Westmorland when a young man, purposing to live by teaching and the production of scholarly textbooks. He settled first in a byway of the old London that has long since vanished, Ship Court, Old Bailey. Married to his landlord's daughter, Anne Gibbons, by whom he had three children, William the first-born and his two sisters, Mary and Ann, he struggled gamely on until middle age, when teaching Latin and Greek and occasional proof-reading were no longer enough to provide subsistence.

A compendious classical dictionary on which he spent some years of labour failed to attract a publisher. There is an endearing simplicity in his plan to establish a Latin- and Greek-speaking coffee-house in the historic St John's Gate, Clerkenwell. The plan had no success. That the coffee-house frequenters would exchange the gossip of the day in a dead language was too much to expect. Richard Hogarth was arrested for debt and consigned to the Fleet

6

prison, remaining in its 'Black and White' Court for some four years from about 1708 to 1712.

A place of detention since medieval times, though burnt down in the Great Fire and afterwards rebuilt, the Fleet took its name from the tributary of the Thames that ran close by. At one time worthy to be called a river, navigable for some distance by barges, it had deteriorated in the course of the centuries to the 'Fleet Ditch'. Far from the springs of its origin in rural Highgate, on its way through the slums and rookeries on either side from Holborn to its outfall near the site of Blackfriars Bridge, the Fleet Ditch brought with it every kind of rubbish and pollution. Alexander Pope in *The Dunciad* pictured his enemies as wallowing in the filth of

> The king of dykes! than whom no sluice of mud
> With deeper sable blots the silver flood ...

The stench that pervaded its neighbourhood added to the grimness of the prison. Corruption of another kind marked its administration.

The office of Warden could be bought and farmed out with profit to a deputy who recouped himself by what he could extort from the unfortunate prisoners, as also did his underlings. The treatment of the prisoners varied according to the amount they were able to pay. There was a 'Master's Side' for those who could afford its superior comfort and a 'Common Side' for the hopelessly destitute. A dispensation the Hogarth family obtained was that of living 'within the Rules'. The 'Rules' were a kind of bail that allowed the debtor to go about within a limited radius from the prison on payment of security, money and fees to his gaolers. It was possible to play skittles and racquets in the bleak courtyards, to join in bibulous parties under the eye of a turnkey who also let out rooms for rent. It was even possible to contract a 'Fleet marriage', the wedding ceremony being performed by one or other of the displaced or pretended parsons who haunted the environs of the prison and solicited custom.

A survey of what might ironically be called 'amenities' could not disguise the horrors of the Fleet such as a Parliamentary committee of inquiry revealed in 1729, at the examination of the Warden by title, John Huggins, a solicitor, and his deputy warden, Thomas Bambridge. Huggins may have been only indirectly in-

volved. At a later date he and his son, William, were on friendly enough terms with Hogarth for him to paint their portraits, the senior Huggins with a frowning visage, the son with a more amiable suggestion of the minor man of letters. The inquiry was mainly concerned with Bambridge, on whom the suspicion of murder lay. His atrocities were many. He put in irons one hapless debtor, a Portuguese called Jacob Mendez Solas, and shut him in a dungeon called the 'Strong Room'. In this damp hole, without fireplace or window, permeated by the miasma of the Ditch alongside, the unfortunate Portuguese was shackled for two months and freed only to work like a slave for his persecutor. A hint in the course of the inquiry that Bambridge might return as Warden caused this prisoner to faint and blood to start from his mouth and nose.

The sadistic fury of Bambridge attacked many others, whom he loaded in irons and tortured in various ways, one prisoner at least dying as the result of maltreatment. Charitable contributions for the prisoners were confiscated. Lawyers appealed to on their behalf were bribed or intimidated. If conditions in the Fleet were not so bad as during the Bambridge regime they can hardly be supposed to have been a great deal better when Richard Hogarth and his family were there some years earlier. In the autobiographical notes William Hogarth later put together he made no mention of this early glimpse of the social abyss. It was an experience maybe too painful to dwell on.

He summed up the plight of his father in general terms as an instance of 'the precarious situation of men of classical education'. He remarked on, but without going into detail, 'the difficulties under which my father laboured and the many inconveniences he endured from his dependance being chiefly on his pen and the cruel treatment he met with from booksellers and printers ... ' Yet the sharp-eyed boy who had already started to draw must have been fully conscious of the miserable spectacle the Fleet presented, a foretaste of others he was later to explore.

He was to be in a way an accuser of Bambridge whom he sketched as a spectator at the proceedings against him. Then in his twenties, Hogarth was able to give his pictorial testimony with something of the vividness that Horace Walpole put into words. 'The scene is the Committee. On the table are the instruments of torture. A prisoner in rags, half starved, appears before them. The

poor man has a good countenance that adds to the human interest. On the other hand is the inhuman gaoler. It is the very figure that Salvator Rosa would have drawn for Iago in the moment of detection. Villainy, fear and conscience are mixed yellow and livid on his countenance.' The law was too tender in rebuke and the penalties it imposed, but reform was at least foreshadowed, if its effective realization was far in the future.

3

Apprentice World

What education was possible to a boy so roughly introduced to the seamy side of London life? It would be reasonable to suppose that Richard Hogarth's parental role included that of schoolmaster and that he imparted to his son some rudiments of the Greek and Latin that were his special study, evidence of which is traceable in the artist's occasional scraps of classical reference. Hogarth's notes make mention of his being at school but without specifying what school it was. Whether it was one of the 'charity schools' of the time, products of Puritan and Anglican efforts for popular improvement, remains a question. By his own account he did not take readily to learning. 'Blockheads with better memories' surpassed him. The warning example of his father was no encouragement to learn languages. His exercise books were scribbled over with his drawings. By the time an amnesty released his father from durance in 1712 he was ready for some employment in which his natural bent towards art might have an outlet.

The family settled in Long Lane, a street extending from Smithfield to Aldersgate, then noted mainly for its second-hand clothes shops and pawnbrokers. In Hogarth's own words, it was 'very conformable to my own wishes that I was taken from school and served a long apprenticeship to a silver-plate engraver'. This was Ellis Gamble, who had his workshop among the byways adjacent to Leicester Fields.

When Horace Walpole came to compile his *Anecdotes of Painting* a certain condescension marred his expression of admiration for Hogarth in describing him as 'the son of a low tradesman who bound him to a mean engraver of arms on plate'. No one could be less like a 'low tradesman' than the unworldly scholar who

fought his losing battle in a materialist world; nor, if one assumes that the term 'mean engraver' implies some measure of contempt, does it do justice to a practitioner of a distinguished craft. Ellis Gamble does not stand out so clearly as the Huguenot goldsmith and silversmith Paul de Lamerie, whose great prestige in the first half of the century and since is beyond question. But Ellis Gamble's work, much concerned with the engravings of armorial bearings, lettering and the decorative frame that enclosed them, was also worthy of respect. His trade card* decoratively and with a nice alternation of italic and Roman letters proclaimed him 'GOLDSMITH at the Golden Angel in Cranbourn Street, LEICESTER-FIELDS', who 'Makes, Buys and Sells all sorts of Plate, Rings, etc. Jewells etc.'. A French version, accompanying the English, suggests a link with the centre of European fashion besides a readiness to cater for the considerable French population in his part of London. The engraved handbills of this kind, distributed to customers and likely customers, were a principal form of advertisement. An emblematic figure identified the shop by its signboard. Street numbering had yet to come into use.

Apprenticeship, according to a regulation remaining from the time of Queen Elizabeth I, was prescribed to last for seven years. Hogarth served out this long period from 1713 to about 1719, during which time he learned to engrave coats of arms and heraldic devices on tankards, bowls and salvers and the silver coffee pots and teapots for the refined table usual in a period before porcelain had come to take their place. Some payment in the way of a premium was customary, though what the Hogarth family may have clubbed together to provide is not on record. His work as a junior was anonymous. Attempts have been made to distinguish his contribution to armorial design, but none has been identified beyond doubt. The editor of an extended edition of Allan Cunningham's *Lives of the most Eminent British Painters*, Mrs Charles Heaton, appended a note to his life of Hogarth bearing on this. 'A magnificent melon-shaped teakettle, engraved with heads in medallion and scrolls by Hogarth, on a circular stand, finely chased with masks, scrolls and medallions, and dated 1722, was sold at Lord Willoughby de Eresby's sale in 1869.' The ascription may be doubted if only because by 1722 Hogarth had abandoned his first occupation.

* A copy is in the Guildhall Library.

The craft that provided other middle-class youths with a settled career and a specialization interesting enough to content them for a lifetime, was not for him. It is even surprising that he spent so long a time in the Cranbourn Street workshop—as he explained, through sheer necessity. The length of his stay there would suppose him an industrious apprentice, little though he seems to have resembled that model of correct behaviour and virtuous endeavour, the aptly named Francis Goodchild of the series Hogarth drew in middle age (1747), contrasting the careers of the industrious and idle apprentices. An irony, concealed or unconscious, can be found in the conventionally moral tale, devised, he said, 'for the instruction of the young'. He grew as bored in his own youth by the discipline of the silver plate engraving as the bad boy, Thomas Idle, whom he pictured yawning at a loom in Spitalfields, by his industrial routine. It is easier to imagine him likewise taking time off to read Defoe's *Moll Flanders* than 'performing the Duty of a Christian' with Goodchild's smug piety.

If Hogarth was not an 'Idle' neither was he a 'Goodchild', obediently to follow a prescribed course. The spirit of independence that was to put him in so many defiant attitudes showed itself in this adolescent stage. His impatience with ornamental design in the Gamble workshop and the task of engraving 'the monsters of heraldry' was somewhat ungrateful. He could not see the changes of design in silver in the learned perspective of a later age. None the less they reflected a general trend in the arts to which he was instinctively responsive. Albeit unconsciously he could not but absorb the signs of transition from the weightiness of the baroque style to the lightness and delicacy of the rococo, a transition illustrated by the trade card he designed for the dress shop run by his sisters.

What in a Thomas Idle could be a waste of time was a fruitful alternative of study to the apprentice Hogarth. To observe living beings, he decided, was better training for one ambitious in art than either engraving heraldic monsters or copying what others had done. In his overcrowded London where so much of life was lived in public there was ample material. The periodical fairs that were a lively feature, besides being a popular entertainment, were to an artist's eye a whole encyclopaedia of forms, colours, dramatic movement and human expression. The large open space at Smithfield, once the scene of martyrdom, was a playground where

for three days Bartholomew Fair provided an uproarious spectacle. Crude drama, open-air acrobatics, booths and stalls of all descriptions attracted a vast throng, while beating drums, whistles, the cries of those with things to sell and the roar of the mob added the excitement of sound.

Southwark Fair, established by a charter of Edward VI in 1550, offered similar entertainment, and many of the same actors and actresses took part in the performances staged at each. Professionals as well known as James Quin and Charles Macklin did not disdain to appear in them. The young Hogarth can be imagined on a trip to Southwark Fair in its rural setting on the south side of the Thames (as near to open country as he usually got). One of the masterpieces of humorous observation he was later to produce, the *Southwark Fair* (1733), shows the delight he took in the medley of signboards advertising such spectacles as 'The Royal Waxworks', 'The Trojan Horse', 'The Fall of Bajazet'; the variety of character and action—Figg, the prize-fighter as the travesty of a mounted knight, Cadman, the tightrope walker swinging through the air on the cable suspended between Mint Street and the tower of the old St George's Church; the incidental touches of comedy such as a bailiff's arrest of Tamerlane (in stage costume), the actual fall of performers enacting the fall of an empire from a collapsing stage; the picturesqueness of a stage heroine beating a drum to the trumpet fanfare of a negro boy dressed as a medieval page.

Apart from these carnival occasions the London streets were a tumultuous stage in themselves. Hogarth studied the sea of faces, the fresh and cheerful beauty of the work girls, the harder look of those entrapped in the prostitute's lot, the superior airs of the rich, the furtiveness of the rogue, the scowl of the bully, the creases of laughter, the ravages of disease. Here art could learn direct from nature. Impossible to arrest was the constant movement of this panorama of human expressions, except by looking with an intensity that imprinted the scene on the memory.

Of set purpose, the young man set himself to train this faculty to the pitch of conserving images in all their original sharpness of definition. It was an apprenticeship of a kind different from that of silverplate engraving, pursued in the intervals the latter allowed. As yet his ambition to paint was not clearly formed. The huge decorative scheme on which Sir James Thornhill was at work in Greenwich Hospital (1708–27) stirred his imagination, but a

second start in engraving was as far as his plans went when he had served his term with Ellis Gamble. Soon after Richard Hogarth died, in 1718, his son determined on an independent career as an engraver on copper. Instead of coats of arms he purposed to produce prints for the public, either as book illustrations or as separate engravings of topical interest. He first set up shop when he was twenty-three in the house in Long Lane where his mother still lived.

A wide prospect opened of comment on contemporary life and events, of skirmish on the battleground of ideas. The Dutch had been prolific in the production of political and satirical prints during their struggle for independence. They had an example to give to England where pictorial remark of this kind was still at a rudimentary stage. Its development in the 'Augustan' period of Queen Anne's reign and the reigns of her Hanoverian successors was parallel with the satirical mood so strongly evinced by the men of letters.

4

The Satirist's World

The targets of the satirist make a varied list of institutions, happenings, beliefs and personalities. The weapons used and the purposes involved were various also. The poets had got into the way of conducting their personal vendettas in verse. Satire used in this fashion had no other aim than to attack literary adversaries and critics by deriding their intelligence and ability, even in the most exaggerated terms. Dryden had set the style of this internecine war of poets and playwrights towards the end of the seventeenth century. Even the small men of letters who cared to criticize him became, in his rhyming couplets, giants of obtuseness. A majestic obloquy obscures the merits of the Roman Catholic priest and playwright, Richard Flecknoe who, said Dryden, 'In prose and verse was owned without dispute / Through all the realms of nonsense absolute'. A similar remark gave an unfortunate immortality to the writer of clever comedies, Thomas Shadwell – 'The rest to some faint meaning make pretence / But Shadwell never deviates into sense'.

Alexander Pope followed Dryden in the invention of a hierarchy of dullness. *The Dunciad*, which appeared in 1728, was also the product of his association with the group that met for a while under the title of the 'Scriblerus Club' and made it their amusement and a literary occupation to laugh at 'dunces'. His allies in the exposure of folly included the witty John Arbuthnot and the formidable Jonathan Swift, from whom the suggestion for *The Dunciad* may have come. The work that resolved into a series of onslaughts on those against whom Pope nursed a grievance was merciless to many that deserved better, from the Shakespearian critic Theobald to the Poet Laureate, Colley Cibber.

Satire of another kind was that of Samuel Butler whose mock-heroic poem *Hudibras* remained popular long after its appearance in the later years of the seventeenth century as a caricature of Puritanism and its extravagances in the person of a Presbyterian justice, a burlesque of Don Quixote, with some traits apparently derived from Butler's uncongenial employer for a time, the Puritan Sir Samuel Luke. Like Cervantes's hero, Butler's Sir Hudibras sallied forth in company with his clerk, Ralph, to redress abuses – the result being a series of ludicrous situations. Butler died in obscurity in 1680 but *Hudibras* outlived him. The rough-hewn wit of his rhyming couplets lost none of its popular appeal in the time of Queen Anne and her Hanoverian successors, a period critically disposed towards the warring ideologies of the foregoing century. A satire directed against puritanical kill-joys and fanatic sectarians 'still so perverse and opposite / As if they worshipped God for spite', was in keeping with a general dislike of any such extremes.

The growth of the party system made for satire of a political kind. There was ample material in the rival aims and personalities of the Whigs, so firmly established after 1714 in their support of the Hanoverian succession, and the Tories who were not without some remnants of attachment to the old regime of the Catholic Stuarts. They were the more in disfavour after the attempted revolt in 1715 by the 'Old Pretender', James Edward Stuart. Few could cavil at the increase of trade and the sum of national wealth under Sir Robert Walpole's liberal direction. There was at the same time corruption and controversy enough to encourage fresh development in political caricature.

Prosperity had its pitfalls. The optimism easy to misapply to hopeful financial schemes had its warning examples. In France there was the failure of the 'Mississippi Scheme', promoted by the Scots financier, John Law. England had its counterpart in the 'universal delusion' of the 'South Sea Bubble'. Material for the satirist was the frenzy of speculation in 1720 after the acceptance of the South Sea Company's proposal to pay off the National Debt in return for special privileges. There followed the mushroom growth of uncharted and often bogus companies with absurd projects that took advantage of a brief euphoria, replaced by panic and fury when the bottom fell out of hugely inflated share values.

A subject for virulent comment was the crash, when fictitious accounts were exposed, members of parliament who were also

directors of the South Sea Company were expelled the House and taken into custody, bankers fled and simple-minded investors such as the poet, John Gay, lamented the loss of their imagined fortunes. It is not surprising that the young engraver, William Hogarth, just starting out on his own, should devote a print to the South Sea scandal in 1721, a topic of popular interest and concern.

The print was not so ferociously satirical as it might have been and was to be one of his few excursions into the field of politics. He was not personally involved, having no money to lose in wild-cat schemes or interest in finance beyond what return his own labour might bring. The result was more of a philosophic gener-alization than a satire on anyone concerned. He produced an allegorical design of a kind that had a seventeenth-century ances-try, introducing the wheel of fortune and whipping post in some-what obscure reference to the unjust punishment of Honour and Honesty by 'Self-interest and Vilany ... ' He added as a companion piece later *The Lottery*, which might pass for an indictment of state-sanctioned gambling, an object of long-continuing dispute. But the allegorical figures that presented the choice between virtuous occupation and the greed for gold were too abstract to evoke popular response.

Follies and abuses, or what he thought to be so, of another kind stirred the fighting spirit he was always to show. His concern was with the arts rather than national finance and its aberrations. The contentious atmosphere in which the poets fought their duels and bandied ridicule had its influence. The engraved illustrations for Butler's *Hudibras* that Hogarth produced in his twenties were crude and lacking in personal quality but the idea remained with him of a series of comic adventures exposing the affectations or weaknesses of the principal character. Like many others in his time he was prepared to 'pummel and pound with Hudibrastic cudgels', and in the manner of the belligerent poets, Dryden and Pope, to single out his objects of attack from among the living. His early illustrations were commissioned by booksellers, of whom, remembering his father's disappointments, he had no great opinion. He could express himself more freely and gain more profit in publishing his work himself—which he proceeded to do in *Masquerades and Operas*, 1724, a tilt at 'The Taste of the Town'. In this plate 'the reigning follies were lashed', in his words, with

17

a vigour and freedom of reference to individuals of which the public took notice.

'Taste' as ostensibly satirized by the print was the vulgar preference for the masquerades and other popular performances organized by the Swiss theatre manager, Johann Jakob Heidegger. They were assumed to account for the decline of interest in serious drama. Heidegger, marked by the initial 'H', from a window watches the crowds arriving to see the 'harlequinade' of Dr Faustus while the works of Shakespeare, Dryden, Congreve and Otway are carted away as so much waste paper. But this was only half the battle. The satire also involved Lord Burlington as the presumed source of many errors. The front gate of his town mansion, Burlington House, before which he stands with his architect Colin Campbell, is pictured with the prophetic (and misspelt) inscription of 'Accademy of Arts'. It becomes a monument of the burlesque, surmounted by the Earl's protégé, William Kent. He figures farcically as the centrepiece of a sculptured group in which Raphael and Michelangelo appear as mere subsidiaries.

Hogarth has been doubtfully credited with a print of later date, *The Man of Taste*, but if this was inferior in execution, it pursued the same vein of ridicule, incited this time by Alexander Pope's flattering *Epistle to the Earl of Burlington* and its half-title *Of Taste*. At the gateway of Burlington House, dominated as before by the effigy of Kent, Pope was depicted as a dwarfish figure whitewashing the edifice and bespattering the passers-by under his scaffolding with a rain of plaster, while Burlington mounted a ladder to bring him a fresh supply.

These derisive prints give only a distorted idea of a world which to Hogarth was always strange and uncongenial: that of the patron supporting an obedient circle and in addition favouring the foreigner to the detriment of a home-grown art. To adjust the balance pushed somewhat awry by a one-sided viewpoint it is needful to look more impartially at the work of the man whom Horace Walpole described as the 'Apollo of the Arts' and of his associates.

5

The Rule of Taste

'Taste' meant a good deal more than the young Hogarth's carica-
ture implied. It stood for the respect in which classical standards
were held, the renewal of contact with European thought and
creative activity, the wish to restore the 'brilliance of material
culture' that had impressed Rubens a century before on his visit
to England. As connoisseurs the first two Hanoverian kings were
a come-down after Charles I. The satirical Lord Hervey has left
a sarcastic account of George II's liking for bad pictures, includ-
ing a certain 'gigantic fat Venus' that Queen Caroline of Anspach
vainly tried to get rid of. The court was not the arbiter of taste it
had once been. There were others to pursue, as best they might,
the tradition of culture established by the great collectors of art
and antiquities in Charles I's time.

Sir Robert Walpole himself, far from being simply the Norfolk
squire of sporting tastes, the master of hounds in the intervals of
politics portrayed by the sporting painter, John Wootton, was a
devotee of painting and sculpture. His agents scoured Europe for
fine examples of the masters. The financier who straightened out
the South Sea confusion was also one of the prudent who sold out
his holding when the shares were at their height and was able to
apply his profit to the rebuilding and enrichment of his Norfolk
manor house, Houghton. The great collection he formed of paint-
ings and classical busts and bronzes, always his delight, included
works ascribed to Titian, Rubens, Rembrandt, Poussin, Murillo
and Salvator Rosa. A later generation was to regret the sale by his
brother's son, the third Earl of Orford, in 1769, of the cream of
the collection to Catherine of Russia, to the eventual benefit of
the Hermitage Museum at Leningrad.

Taste had a wider reference than the making of such a private collection, admirable in choice though this might be. It could imply an all-round view of the arts in a social relationship, an active application of ideas and the encouragement and support of the living. Taste in this sense was a faculty exerted with effect by Robert Boyle, third Earl of Burlington and fourth Earl of Cork. Born in 1694, he succeeded to the title before he was ten. He came into large estates in Yorkshire and Ireland, a London mansion, Burlington House in Piccadilly, and a Jacobean country house and estate at Chiswick. The Grand Tour, which took him to Italy about the time he reached his majority, aroused that interest in the arts he was to develop in a comprehensive way. He became a patron after the style of the liberal-minded Renaissance princes, of architecture, literature, music and painting.

Calm, serious, refined, he appears in his portrait in informal attire, painted by Jonathan Richardson when the young nobleman was in his twenties; impressive at the age of fifty in the richness of ceremonial dress in the Chatsworth portrait by George Knapton, Richardson's pupil. In a tribute to Inigo Jones he rests his hand on a volume of the great architect's designs, while Jones's bust by Rysbrack bears him ghostly company. He leaves the impression of a generous mind and in Horace Walpole's estimate 'had every quality of a genius and artist except envy'. Patronage with him was a duty, in accord with that ethical notion of how riches should be laid out to the best advantage advocated by the philosopher Locke and Locke's pupil, the Earl of Shaftesbury.

The circle that benefited by his friendship and help makes a long and brilliant list. It includes, among writers, Pope, Swift, Gay and Thomson; among musicians, Handel who lodged at Burlington House for three years, and the Italian composer of opera, Giovanni Bononcini; among architects, James Gibbs, Colin Campbell, Henry Flitcroft and in several capacities William Kent; among sculptors and painters, Giovanni Battista Guelfi, Michael Rysbrack, Louis François Roubiliac and Sebastiano Ricci.

It was fortunate that Burlington's wife, Lady Dorothy Savile whom he married in 1721, was able to share his interests. She made portraits in pastel of the foreign actors, singers and dancers of stage and opera who in one way or another came under Burlington's protection. A family portrait of the Earl and Countess and their daughters, by the French painter Jean-Baptiste van Loo who

had some years of success in England, showed them, according to the engraver George Vertue, as 'all disposed in the virtuosi way'. The Earl had his port-crayon to hand; the Countess a palette of oil colours (one might fear for her rich dress of brocade flower'd silk), the daughters their books of cultured study.

Not all Burlington's plans for a general uplift in the arts turned out as he wished. The Royal Academy of Music, of which he was a main supporter, founded in 1719, came to an end in 1728. He may well have thought it a sign of the erratic nature of literary men that the Italian opera he tried hard to foster was laughed off the stage by John Gay's *The Beggar's Opera* – the work of one who had enjoyed a long stay at Burlington House and addressed his patron in flattering terms as 'belov'd of all the Muses'. Protégés were apt to be disappointing. Speaking of the Italian, Guelfi, George Vertue remarked that 'Ld Burlington parted with him very willingly'. Guelfi's reported conviction that 'as an Italian, nobody could be an equal to himself in this country', was too arrogant a claim, though before he departed to Bologna in 1734 he had produced at least one influential work. This was the monument in Westminster Abbey to James Craggs, Secretary of State, for which Burlington gained him the commission. The reflective pose of the standing figure with legs crossed, leaning on an urn, was to be much imitated and had its most famous adaptation in 1740 in the Shakespeare Monument in Westminster Abbey, by William Kent and the sculptor of Flemish origin, Peter Scheemakers.

Directly and indirectly Burlington had his part in encouraging the sculptors who established a new phase of monumental design in England, not only Scheemakers but also the Antwerp-born Michael Rysbrack, from whom the Earl commissioned the statues of Palladio and Inigo Jones for his villa at Chiswick. His friend and admirer, Alexander Pope, added his encouragement to the best sculptor of them all, Louis Roubiliac, impressive alike in monuments and portrait busts. But Burlington's principal achievement was in architecture and in furthering a revised form of classical style and idea.

That architecture should be based on that of the ancient classical world had been generally accepted in Europe since the Renaissance period, though subject to various amendments and complications. In England a contrast was clear between the conceptions of Sir Christopher Wren and those of Inigo Jones. Wren, who never

visited Italy, learned much from France and Holland. Jones, on the other hand, was linked with Italy by travel and study of the Italian treatises that seemed to draw a straight line of tradition from Vitruvius in Rome of the first century B.C. to Andrea Palladio in the sixteenth century. The example of Palladio and Jones guided Burlington in a new programme for architecture different from that of Wren and more strictly classical in its order and symmetry. By his own designs and those of his architect allies he gave an influential example to a succeeding generation. Burlington House was remodelled, largely by Colin Campbell, a powerful advocate of the Palladian style. It was his imposing gateway at the Piccadilly front of which Hogarth made satirical use in his squib against the Rule of Taste. This and the courtyard colonnade by James Gibbs, admired as worthy of ancient Rome, belong to the past. Victorian alterations were to disguise the building but traces of its interior splendour are still to be seen. Burlington's villa at Chiswick, on the model of Palladio's Villa Capra near Vicenza, restored in the twentieth century as nearly as possible to its original aspect in 1729, remains an elegant showpiece. Never intended solely for domestic use ('too small to eat or sleep in and too large to hang on the watchchain' was Hervey's sarcastic comment) it was suited to learned reverie. The effect of a Palladian shrine was completed by Burlington's henchman, William Kent, who borrowed motifs from Inigo Jones's designs in the interior décor and designed the gardens that were in themselves a forecast of later developments. They were partly inspired by Alexander Pope's ventures in landscape gardening in neighbouring Twickenham. Kent took advantage of the poet's thought of an ancient and calculated deference to wild nature exemplified in the sylvan retreats where Roman philosophers and poets had delighted to muse. In the provision of surprises, contrasts and seemingly limitless vistas artfully contrived he was typically ingenious.

Kent, described by Horace Walpole as Burlington's 'proper priest', was the main target of Hogarth's attack which showed his little sympathy with the wider range of the movement Kent had his part in and his own preoccupation with painting. He ignored the brilliant architect, the decorative designer of fertile invention, the pioneer of landscape gardening and concentrated on the shortcomings of the painter.

Kent in a way was the artist Hogarth might have been – if he

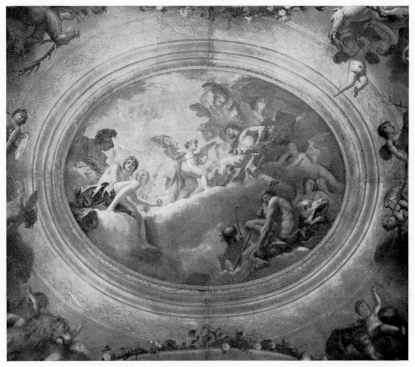

1 Sebastiano Ricci, ceiling painting, *c.* 1715, Burlington House

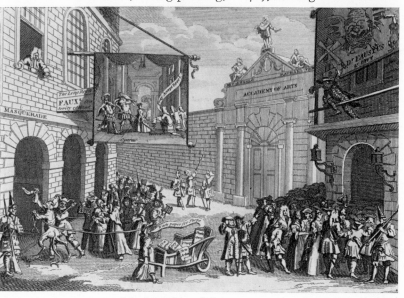

2 *Masquerades and Operas,* 1724

3 *Assembly at Wanstead House, 1729–31*

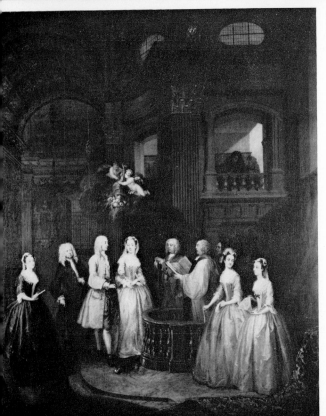

4 *The Wedding of Stephen Beckingham and Mary Cox, 1729–30*

had not been Hogarth—though this is as much as to say they were diametrical opposites. Born at Bridlington in East Yorkshire of poor parents, he had a spectacular rise to success. Early drawings made when he worked for a coach-painter at Hull persuaded a group of Yorkshire gentlemen to send him to Rome to study. There he had training in the studio of the Florentine painter and teacher, Benedetto Luti, and supported himself by selling pictures and copies of old masters. With the gift, which Hogarth never had, of making himself agreeable to a patron he gained the notice of Burlington while in Rome. The Earl brought him back to England and installed him in Burlington House where he spent the rest of his life in cheerful dependence. Through his patron he obtained responsible posts in the Ministry of Works, was appointed Master Carpenter in 1726, Master Mason and Deputy Surveyor in 1735. He applied himself with the utmost confidence to a variety of undertakings from the interior scheme of the Chiswick villa to the architectural magnificence of Lady Isabella Finch's house in Berkeley Square (the still existing No. 44) and the picturesqueness of the Horse Guards building in Whitehall. He was as ready to design a fanciful baby carriage for the infant Prince Henry Frederick as a royal barge for Frederick, Prince of Wales.

Talented in so many ways, Kent was of no great consequence as a painter, though not to be deterred from decorating large areas of wall. We have Horace Walpole's word for it that his colour in mural paintings at Houghton was thought so deplorable that he was constrained to finish them in monochrome. His altarpiece for St Clement Danes (eventually removed) invited parody. With typical bluntness Hogarth said of him, 'Never was there a more wretched dauber that soonest got into palaces in this country'.

There were several reasons for what might seem over-emphasis in this pronouncement. The example of Kent brought out the partiality of patronage. It was, for instance, with the weight of Burlington's influence on his side that Kent was able to obtain the commission for an extensive decorative scheme at Kensington Palace, including the mural with many figures after the Venetian style (that fell, however, far short of Veronese) for the Grand Staircase, and the glitter of the Cupola Room that shocked George Vertue by its blatancy.

The preference given on this occasion to Kent rather than to Sir James Thornhill, who had more serious qualifications for the

work, made additionally clear that an aristocratic patron's circle was also a closed one – closed that is, however widely embracing it might appear, to those of independent mind. Kent was, exceptionally, given wide scope. For painting on the grand scale – or painting that could be regarded as 'high art' by reason of its lofty subject matter – it was generally assumed a necessity to look abroad and especially to Italy.

It was natural enough seeing that what was known as 'history painting' – the large-scale composition on a classical or religious theme – had been little practised in England, whereas in continental Europe it had the encouragement of both Church and State. Painting was one of the instruments of absolute authority; of the Church seeking to affirm its hold on mind and emotion by dramatic scenes and celestial vistas conveyed in the baroque style that had become dominant in the seventeenth century; of the power and magnificence of the secular prince, expressed by similar means. A change was coming about in Italy and elsewhere when Hogarth lived, a lessening of tension, a move towards luxurious elegance rather than grandeur as the lighter style known as rococo emerged. In France the stern authority of Louis XIV might be replaced by the relaxed and frivolous atmosphere of the Regency and the reign of Louis XV, but style in the arts tended to remain a comprehensive system defining the monarchical and aristocratic ways of life. The arts thus kept an artificial consistency with the nature of the regimes they served.

It is easy to understand why an England that had long since done with absolute monarchy and lacked any strong inclination towards a religious orthodoxy should have no corresponding native tradition. There were settings enough for large decorative schemes but who should carry them out seemed a question best solved by reference to the artists of Bologna and Venice. Connoisseurs from England on the Grand Tour made such contacts when in Italy, though Italian artists were numerous among the foreigners who came to England on their own initiative.

Their tendency to travel was a feature of the age. With all the confidence of adepts in an inherited tradition and no special attachment to any one place they offered their services to whatever state in Europe sought to affirm a princely and ecclesiastical magnificence. There was a separate inducement to visit England in the fabled munificence of the rich milord. Taking patronage

as their due, wherever they might happen to be, the Italian paint-
ers roamed through the states of the old Holy Roman Empire,
Austria, Bavaria, the Palatinate. They sampled London inciden-
tally as visitors of international status rather than settlers.

An early arrival was the Venetian, Antonio Bellucci, who worked
in Vienna for the Emperor Joseph I and came to England from
the court of the Elector Palatine in 1716, finding a patron in the
Duke of Chandos. He stayed until old age and the gout caused
him to go home in the 1720s. A visitor of greater brilliance about
the same time was Antonio Pellegrini who applied a Venetian
charm of style to the decoration of the Earl of Manchester's London
house and also of Castle Howard, before leaving in 1721 for the
service of the Elector Palatine.

A kindred spirit was the Venetian, Sebastiano Ricci, who to-
gether with his nephew, Marco Ricci, stayed in England for four
years, from 1712 to 1716. Sebastiano, who 'made the tour of all
Italy, employing his pencil wherever he received commissions at
any price' and thence went on to Vienna and London, is noted for
a decorative style that had its origin in his admiration for Veronese.
His principal works in England were the altarpiece *The Resurrec-
tion* in the apse of Chelsea Hospital Chapel and the wall and ceiling
paintings he executed for Lord Burlington at Burlington House.
Within the Victorianized framework of the latter remains the
elegance of Ricci's staircase paintings, *The Triumph of Amphitrite*
and *Diana and her Nymphs*, the airy confection of the ceiling in
what was to become the Royal Academy's Council Room.

A later visitor was Jacopo Amigoni, a Neapolitan by birth but
brought up in the Venetian tradition. He worked for some time
in Bavaria before coming to England in 1730. In a stay of nine
years, before the nomadic habit of his kind took him to Spain, he
produced many mythological and 'history' subjects, decorative
but with some lack of imaginative life that caused Horace Walpole
to remark that his figures seemed like actors in a tragedy, formally
posed in waiting for the curtain to go up.

This succession of Italian artists, able if not of supreme stature,
came near to having a monopoly of the large-scale decoration
suited to buildings of importance. It is even surprising that Sir
James Thornhill, almost unique in this early part of the century
as an English practitioner of 'history' painting in the baroque
manner, should have been employed on large commissions as

often as he was. One of a family of country gentry in Dorsetshire, he was a pupil of Thomas Highmore, Sergeant-Painter to William III, and drawn towards decorative painting by the example of Louis Laguerre and Andrea Verrio, the facile executants described by Pope in the couplet that derided them with a verb:

> On painted ceilings you devoutly stare
> Where sprawl the saints of Verrio or Laguerre ...

At Hampton Court, Thornhill made copies of the Raphael cartoons and though he never went to Italy was able to assimilate elements of the Italian mastery of illusionist perspective from the published designs of Fra Andrea Pozzo, the Jesuit lay brother who was one of the artists who brought the pictorial drama of the baroque to Austria and Southern Germany. Principal among Thornhill's works were the grisaille paintings in the dome of St Paul's and the decoration of the Painted Hall at Greenwich Hospital that occupied him from 1708 to 1727.

He had some advantage in royal favour, was knighted by George I and appointed Sergeant-Painter in 1720. It is evident that he got on well with the architect Nicholas Hawksmoor at Greenwich, from the harmony that appears between the great interior and the complex scheme of design with which he adorned walls and ceiling. Yet, less amenable than Kent, he remained outside Burlington's circle of the élite. He was a competitor with both Kent and Burlington's favoured Italian painter, Sebastiano Ricci – and not always unsuccessfully so. He was chosen to decorate a royal apartment at Hampton Court in spite of the preference for Ricci shown by the Lord Chamberlain, the Duke of Shrewsbury. He secured the commission to decorate the dome of St Paul's in the face of Ricci's rivalry – as well as the claims of Louis XIV's godson, Louis Laguerre. Two such defeats were more than the Venetian could bear. He and his nephew went back to Venice in 1716. Sebastiano's work at Burlington House was left incomplete – to be finished by Kent.

As Sergeant-Painter in 1722, with the great work at Greenwich well under way, Thornhill might reasonably have expected to decorate the State Apartments at Kensington Palace. The cheese-paring economy that pursued an artist accustomed to paint at so much per square yard (£3 a square yard for the Greenwich ceiling and £1 a square yard for the walls) made his estimate of £800

unacceptable. Kent who was assigned the commission charged only £300. Besides the economy, the formidable weight of Burlington's support tipped the balance. He 'forwarded Mr Kent's Interest as much as layd in his power at Court', George Vertue commented in his *Notebooks*, '& strenuously oppos'd Sr James'. Such was the power of patronage against which Hogarth made his stand.

6

The Making of a Painter

It was Thornhill who first fired the young man's ambition to paint.
'The paintings of St Paul's Cathedral and Greenwich Hospital
which were at that time going on ran in my head,' Hogarth was
later to observe. So far as they represented the 'grand style' of
alien origin they might have been thought uncongenial, but he
was enthralled by their skill of execution. The paintings at Green-
wich were the celebration of a triumph as Rubens's great ceiling
of the Banqueting Hall in Whitehall had been, except that in its
elaboration the triumph was of a different order. Rubens in the
Apotheosis of James I had symbolized the divine right of kings, in
the, however unlikely, similitude of 'the royal image tending to-
wards eternity', the authority of the Stuart dynasty as the fount of
Justice and Wisdom, victorious over Ignorance and Discord. It
was scarcely possible to depict in the same way the accession of
William III and his Queen or to see, without considerable reserva-
tions, the advent of a new Golden Age in the arrival from Hanover
of George I. In place of the affirmation of divine royal rights the
Greenwich paintings marked the downfall of Tyranny as repre-
sented by Louis XIV, the offer of the 'Cap of Liberty' to Europe,
the victories of the nation at sea. The profusion of allegorical
figures of Virtues and Vices and emblems as classical as Apollo
and Diana, gave religion only a sidelong allusion in the figure of
St George overcoming the dragon. If the massive force of
Rubens was beyond rivalry, the effect was still splendid, as
Hogarth was to assert in spirited defence, in the letter he wrote to
the *London Magazine* in 1737, appropriately signed 'Britophil': 'I
am certain all unprejudiced persons with (or without) much in-
sight into the mechanic parts of painting are at first struck with

the most agreeable harmony and display of colours that ever
delighted the eye of a spectator ... '

How far the 'protestant Baroque' of the Painted Hall, master-
piece of its kind as it might be, provided an example to follow,
was a question. What, indeed, was the future of 'history' painting?
Painters in Europe were giving their answer by turning towards
a milder narrative style, as the fervours of the seventeenth century
spent themselves. Biblical and mythological themes were more
gracefully than forcefully treated, the heaviness of shadow once
used to express an intensity of feeling was lifted. When Hogarth
spoke with horror of 'the shiploads of dead Christs ... and other
dismal, dark subjects' imported into England, it may be guessed
that he had in mind the sombre products of the seventeenth-cen-
tury Spanish-Neapolitan School and copies of them such as were
frequent in the auction rooms of London.

In contrast to this religious gloom or the lighter play of decor-
ative fancy was art that aimed at truth, such truth as the spectacle
of everyday life could afford. Europe was not lacking in example.
In France Antoine Watteau turned from the *fête galante* to such a
realistic marvel as his final masterpiece, *L'Enseigne de Gersaint*, the
actuality of an art-dealer's showroom and its clientele. The pro-
priety of French middle-class life made for a mood of painting in
the work of Chardin quite different from that of the playful
mythologies of Boucher. In Venice, the heights of decorative
daring reached by Tiepolo had their mundane opposite in the
painting of the contemporary scene by Pietro Longhi.

A young man in early eighteenth-century London with plenty
of intelligence but with little knowledge was in no position to
grasp the trend of art in Europe in all these variations. The ailing
Watteau's visit to London in 1719, to consult the internationally
renowned physician Dr Richard Mead, passed without notice,
though later in the century his work was known and inspiring to
Gainsborough and Reynolds. What the young Hogarth could see
or know of what, as he termed it, 'the puffers in books call the
great style of History painting', bred a complex state of mind, com-
prising doubt of its nature and purposes and at the same time the
urge he never lost to see what he himself could do in this line. The
feeling for reality pulled him in an opposite direction, if not so
far as he might have thought, from the trend of Europe in an age
of transition.

Though Hogarth's autobiographical notes penned at a late stage of his career reveal this complexity of attitude they have all too little to say of how he acquired his mastery of the craft of painting as distinct from that of engraving, the beauty of paint substance, the clarity of colour, sometimes lost sight of in the interest aroused by his subject matter. What indeed was the starting point of a painter in the early eighteenth century?

He might pick up something of technique as an assistant in the studio of a successful portrait painter, portraiture being the branch of art that flourished beyond all others. If he could afford to travel or was, like Kent, one of the favoured few who were enabled to do so by a patron's subsidy, he might find a training ground in Rome and the instruction of a teacher such as a Luti or an Imperiali or some other minor painter who took foreign pupils.

Both methods of instruction are exemplified in the career of the Irish painter, Charles Jervas, who came from Dublin to work under Sir Godfrey Kneller for a time, when he was about twenty years of age. Like others with a yearning towards 'high art' he made copies of the Raphael cartoons at Hampton Court which he sold to Dr George Clarke of All Souls, Oxford. Dr Clarke lent him £50 in 1699 to travel to Italy where he stayed about ten years, becoming known as Carlo Jervasi, and making copies of various Italian masters. He was then over thirty, according to George Vertue's critical remark, 'having learnt the art of painting at the wrong end', though the prestige gained in Italy furthered his success in portraiture on his return in 1709. He painted Dean Swift and Alexander Pope, to whom he gave lessons in drawing, and was distinguished in that intellectual circle by making a new translation of *Don Quixote* (for which Hogarth was to supply a series of engraved illustrations). Held in small esteem as a painter by fastidious critics, Jervas cut an imposing enough figure to be appointed Painter to the King in 1723 in succession to Kneller.

Hogarth's beginnings as a painter were of a different kind and not altogether easy to trace. A craftsman's living was to be found in painting shop-signs and his experience of engraving trade cards first turned his thoughts in that direction, to judge by early efforts such as a paviour's signboard he is reputed to have painted, awkward in manner but characteristically observant of London life and labour. His theory that the way to become a painter was by looking, that is by training the memory to keep the imprint of

expression and gesture, was to serve him well but was scarcely the means of learning how to use a paint-brush. London had for a long time lacked a centre of art education and a meeting-place for both young and mature, though the need was recognized by the principal portrait painter of the Augustan years, Sir Godfrey Kneller. The academy for painting and drawing he established in 1711, adjacent to his town house in Great Queen Street, was to pass through various phases but eventually in a later form played its part in Hogarth's development.

⚈⚈ 7 ⚈⚈

Academies in Embryo

Sir Godfrey Kneller, born Gottfried Kniller at Lübeck, was sixty-five years of age in 1711. Trained in Holland under Ferdinand Bol and Rembrandt and after a period in Italy, he had come to England when he was thirty and grown rich and successful by the many portraits he executed during the reigns of Charles II, William III and Queen Anne. Portraiture had nationalized and knighted him as it had his predecessors, Sir Anthony Van Dyck and Sir Peter Lely. He organized it, so it was said, 'upon as regular principles as the fabricating of carpets at Kidderminster'. A man of importance, he travelled in his coach drawn by six horses between his town house and the country mansion, Whitton, which he had built in 1709 at Twickenham, with its deer park and vista of formally laid-out gardens. He was still at work on his great *tour de force*, the likeness of members of the Kit-cat Club, the distillation of Augustan society and talent, that occupied him for twenty years, when he founded his academy.

Criticism was to deal harshly with Kneller. To those who thought it almost the duty of an artist to be penniless, the wealth gained by portraiture was an object of suspicion. To Horace Walpole he was a signal instance of the low ebb to which the arts in England were sunk in the early years of the eighteenth century. 'Where he offered one picture to fame, he sacrificed twenty to lucre' was the remark of one whose indifference to lucre did not prevent him from enjoying the comfortable sinecure of Comptroller of the Pipe and Clerk of the Estreats. But apart from the assessment of the painter, which indeed needed more than an epigram, little could be said against the liberal and

intelligent move that was designed to bring artists together.

Sixty of them met in Great Queen Street in October 1711 to elect a governor and twelve directors. Kneller was unanimously declared governor. The chosen directors included the decorative painters, Louis Laguerre and James Thornhill, the portrait paint-ers, Jonathan Richardson and Thomas Gibson, and the sculptor who had worked for Wren at St Paul's, Francis Bird. Among the electors and first members of the academy, George Vertue is to be singled out as one who was to prove indispensable in comment on English art and artists in the first half of the century. Born in the parish of St Martin-in-the-Fields in 1684, Vertue, like Hogarth, was first apprenticed to a silverplate engraver. Much of his work later consisted in engravings after portraits by Kneller and his Swedish rival, Michael Dahl, Richardson, Jervas and others. Among their sitters he gained a number of influential friends, such as Robert Harley, Earl of Oxford, who 'gave me great reputation and advantage'.

Vertue, a man of modest personal ambition, was insatiably curious about art and artists, on whose work and character he made copious if oddly written notes, jotted down in the diaries he filled to overflowing, shrewd critical remark being seasoned with current gossip and amusing anecdote. He meditated a history of art in England and made numerous journeys about the country under the aegis of one or other of his friends and patrons to see the great collections. He became engraver to the Society of Anti-quaries and showed an equal interest in antiquities of various kinds, of which he compiled graphic records. He made modest sketches of his own in water colour besides his work as a copyist, one such drawing being that of his wife and himself on their wedding day in 1720. With a pleasant naïveté it shows them 'in the very habit they wore' and clasping hands.

Vertue had previously made a point of frequenting the artists' clubs and taverns where they gathered sociably. But observation in the convivial atmosphere of such a meeting-place as the 'Rose and Crown' club had been more costly than his limited means wanted. Kneller's academy gave him less expensive opportuni-ties of studying the artist fraternity at work. Through his eyes one can see the 'large room, ground floor in the great house in the middle of Great Queen Street, near Lincoln's Inn Fields', a mansion decayed and otherwise uninhabited, where subscribers

to the academy could draw, the subscription being 'a guinea for each person, paid down'.

For some years the combination of meeting-place and life school seems to have run smoothly enough, though members were various in age, position and nationality. They included such professionals-to-be as the young Bartholomew Dandridge, who carried on as a portrait painter in Kneller's house after Sir Godfrey's death and was later to vie with Hogarth in the production of conversation pieces. There were amateurs of all sorts: the Irish dramatist and theatre manager, Owen McSwinney, who was to retire to Venice and become an agent for Italian artists; Marcellus Laroon, son of an immigrant French painter, a man of many parts, and even, surprisingly enough, the essayist Sir Richard Steele.

Then the disintegration to which artists' unions are liable set in. The academy took a tortuous course. James Thornhill, who had aspired to be governor, was elected in 1716 on Kneller's resignation. In 1720 a breakaway group from Great Queen Street set up another academy in St Martin's Lane in what had been a Presbyterian meeting-house. The promoters were Louis Chéron and John Vanderbank, both of French origin, who may be thought to have brought with them something of French outlook. Chéron, who had been trained in Paris and Rome, was praised by Vertue as 'very communicative of his art with a plain, open sincerity that made him agreeable and beloved'. Vanderbank, whose extravagance and excesses Vertue deplored, nevertheless was rated by him as 'in the art of painting and drawing, of all men born in this nation, superior in skill'. It is on record that Hogarth studied with them, though he makes no mention of it.

The enterprise did not succeed. It came to an abrupt end when the studio properties were seized for rent, after the treasurer had embezzled the funds. Thornhill took the initiative once more with a reorganized academy at his house in the fashionable Great Piazza of Covent Garden. Hogarth joined in 1724 and thus came into closer contact with the artist he had so long admired. At the age of twenty-seven Hogarth could scarcely be reckoned a beginner. Nor was he overly devoted to the life class that was a principal feature. But acquaintance with one so expert as Thornhill in the deft arrangement of a group and the technical ways and means of manipulating oil colours cannot but have been of service in com-

pleting the engraver's education. He soon became more of a friend and collaborator than a mere tyro or hired assistant — and a member of the family when in 1729 he made his runaway match with Thornhill's daughter, Jane.

Romantic Interlude

The gleam of romance strikes with suddenness in a career so far apparently obsessed with the anxieties and politics of the studio, relieved only by the general entertainment that London life afforded. Hogarth, at the age of thirty-one, short in stature (a 'five-foot man' he was called), made up for his lack of inches by the energy of his personality, the sharp intelligence to be discerned in his bright eyes and full brow (slightly dented through an accident), to be appreciated in his brisk and emphatic way of talking. There was a Cockney liveliness in his features, the tip-tilted nose (a family trait that appears also in his portrait of his sister Ann), the cropped head and disregard for any kind of pretentiousness in outward habit. Forthright and fearless in his expressions of opinion he was inclined to a confident assertion of his own powers that led him too readily to run down others, as the fair-minded Vertue, shocked by what seemed to him a presumptuous conceit, noted with disfavour.

Jane Thornhill was able to form a more tolerant view of her father's bold and opinionated helper. Twelve years younger than he, she was good-looking – the handsome model, supposedly, at a later time of Hogarth's *Sigismunda*, sensible enough to appreciate his obvious gifts and ready to settle down to tranquil domesticity. An instant proposal of marriage was in keeping with his character and the ceremony involved no farther excursion from Covent Garden than the moderate distance to Paddington Old Church. His laconic statement, simply that he 'married' (in 1729), leaves detail of the affair to the imagination. The stages of the courtship remain obscure. That Sir James should have displayed some parental indignation when presented with the accomplished fact,

that coolness should for a time prevail between the couple estab-
lished in the Little Piazza, Covent Garden and the house in the
Great Piazza, is likely enough. After two years, however, the
young Mr and Mrs Hogarth, restored to the fold, were accepted
as part of the Great Piazza household and there stayed until short-
ly before Sir James Thornhill's death in 1734.

The years during which Hogarth had become intimate with the
Thornhill family had also been a period of decisive development
in his art, of which his own narrative gives only a bare and highly
condensed outline. The engraver of satirical prints and hack
illustration had turned into a painter of masterly powers. A new
relation to his world appears in the influence of the theatre, first
declared in the success of Gay's *The Beggar's Opera* and the success
of Hogarth's painted versions of its most dramatic scene. At about
the same time he embarked on portraiture in the form of the small
'conversation piece'. Both were pregnant with the possibilities he
was to utilize in the great panoramas of social life that were still to
come.

A separate and incidental question arising from his connection
with Sir James's academy was what to do about it after his father-
in-law died. There seemed no help for it but to take on a measure
of responsibility for its continuance elsewhere. To the Academy
revived in Peter Court, St Martin's Lane, he contributed the re-
maining studio props, 'a proper table for the figure [i.e. model]
to stand on, a large lamp, iron stove and benches in circular form'.
A painting preserved in the Royal Academy depicts an interior so
equipped and the students at work. It was a turning of the tables
that the rebel who derided Lord Burlington's house as 'Accademy
of Arts' should be placed in the position of running an academy
himself. Of more immediate concern to the artist was what living
he might make by portraiture.

~ 9 ~

'Phizmongers' and Others

Portrait painting, Hogarth remarked, with his habitual force of statement tinged with disrespect for his contemporaries, was 'the chief branch of the art by which a painter can procure himself a tolerable livelihood and the only one by which a lover of money can get a fortune'. It was a highly competitive industry with a great number of practitioners, some with the small and flattering talent that Hogarth scornfully dismissed, but others with more ability than his prejudices would allow. The term 'phizmongering' which he used with so much relish has tended to create a poor opinion of all and sundry in the first half of the century, with little discrimination.

What exactly was a 'phizmonger'? The term referred especially to the painters with many commissions who were content to make the sketch of a head and leave it to employees to fill in the details that completed the picture. Some of these helpers were highly skilled without being ambitious to produce original work of their own. One such, whom Vertue knew and described, was the Fleming, John Peeters, one of Kneller's principal assistants, 'a lover of good company and his bottle', widely known as 'the Doctor' from his ability to restore and retouch. Another native of Antwerp, Joseph Van Aken, was chief among the 'drapery men' who served those who could not or would not do more than paint a head. Vertue speaks of his 'excellent, free, genteel and florid manner of pencilling silks, satins, velvets, gold lace, etc.' much to the benefit of works by several painters. The only trouble was that in consequence they tended to look alike – as Vertue did not fail to notice.

From the number of his assistants and the use he made of them

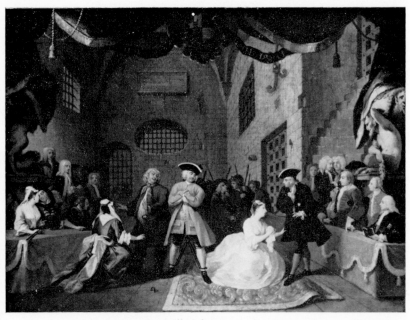

5 *The Beggar's Opera*, 1729–31

6 *A Harlot's Progress*, 1732. Detail of Scene II

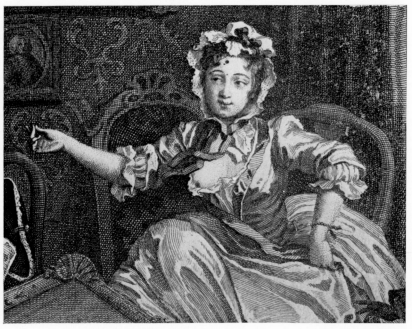

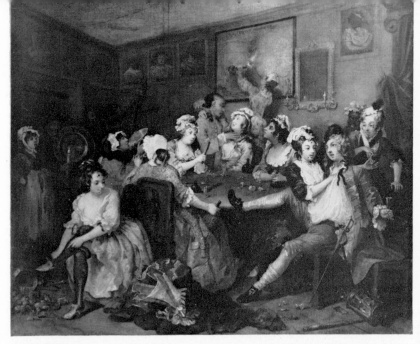

7, 8 *A Rake's Progress*, 1735. Above: the Tavern scene.
Below: the Madhouse scene

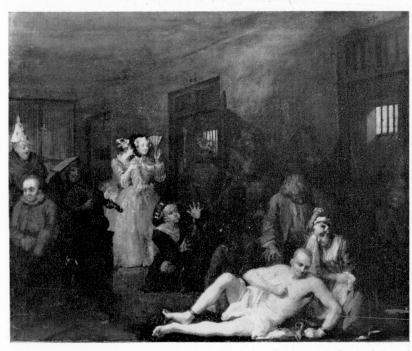

9 *Strolling Actresses Dressing in a Barn*, 1738. Detail

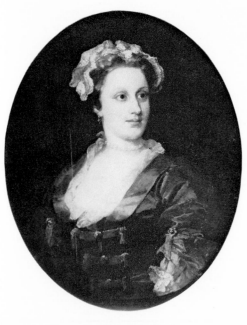

10　*Portrait of Lavinia Fenton, c.* 1740

11　*Captain Thomas Coram,* 1

12　Anon., *The Life School at St Martin's Lane, c.* 1740–50

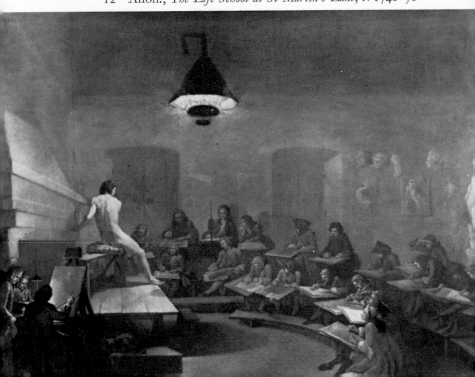

as almost factory hands, Sir Godfrey Kneller might be thought of as the arch 'phizmonger', though in his most personal productions he was far from being as mechanical as the term suggests. There was only a superficial sameness in the set of portraits of the Whig notabilities who met at the tavern of Christopher Cat and gained the name of the Kit-cat Club from the mutton pies there provided and known as Kit-cats. The effect of sameness was the similarity of wig and the size of canvas rather than monotony of pose or expression. The standardized Kit-cat canvas, about 28 × 36 inches, adapted to a life-size three-quarter length, enabled him to include the hands of his sitters with a variation of character and attitude that makes them as distinct as in facial features.

Though Kneller's achievement was belittled after his death in 1723, he had lessons of value for those who followed him. He was a forerunner of Hogarth in the simplicity and directness of his painting and the sense of character in such a work as his portrait of the bookseller, Jacob Tonson, is close to Hogarth's own.

In this competitive profession it was an advantage in securing sitters to have painted a member or members of the royal family or other persons of eminence. Painters used every effort to reach this superior plane, in ways that Vertue with an habitual dislike of pushing or devious methods often found occasion to deplore. An instance is given by Joseph Highmore, who drew in Kneller's academy and afterwards with Chéron and Vanderbank in the academy in St Martin's Lane. He made an early start on his own. When Kneller died in 1723 (wishful at the last that God would let him stay at Whitton instead of sending him to Heaven) Highmore was on the road to success. A eulogist could write

> No more let Britain for her Kneller grieve
> In Highmore see a rising Kneller live...

It was a shrewd move to collaborate with an engraver in an illustrated record of the ceremonies attendant on the installation of Knights of the Order of the Bath. The work, published in 1730, won him many commissions from the Knights and their Esquires though Vertue was repelled by its being advertised with 'the boldest epithets of merit'. Worse in his view was the artfulness of Highmore when he failed to get a sitting from George II and his Queen, Caroline of Anspach. He 'did by stealth draw them first on paper ... and afterwards by Memory in some parts &

copying those pictures before painted by Sr G Kneller'. The pictures so made and subsequently engraved gave the misleading impression that they had been a royal commission.

Hogarth was quickly disabused of any idea of painting royalty by the opposition he encountered when he sought to try his hand at state portraiture. The marriage of George II's daughter, the Princess Royal to the Prince of Orange, even though it had its sad aspect in the deformity of the Prince (described by Lord Hervey with cruel zest) was an historic occasion Hogarth wished to record. He gained the permission of Queen Caroline to attend the ceremony and make his preliminary studies. He duly put in his appearance. But he had reckoned without William Kent, who as a high official in the Ministry of Works was responsible for the accompanying decorations. Kent had his own plan to record the wedding scene. In addition he had an old score to settle with the man who had ridiculed him in caricature.

A member of Kent's staff ordered Hogarth to stop work, despite his protest that he had the Queen's authority. The Lord Chamberlain in person called on him to withdraw. The Queen, when appealed to, could only say she had not realized that the permission given to Hogarth might interfere with Mr Kent's plans. It was a double defeat. Hogarth had already roughed out another work, a royal family group. An individual portrait of the young Prince William, Duke of Cumberland, later the ruthless victor of Culloden, was the only item so far complete. The family group was halted and never taken farther.

George Vertue summed up these 'sad mortifications to an ingenious man' with his always keen sense of the machinery, and machinations, of the art world, and some feeling, evidently, that Hogarth brought the mortification on himself: ' ... it's the effect of caricatures with which he has heretofore touch't Mr Kent and diverted the town – which now he is like to pay for when he has least thought on it. Add to that there is some other causes relating to Sir James Thornhill whose daughter is married to Mr Hogarth and is blended with interest and the spirit of opposition.'

The frustrated attempts to paint royalty were a side issue in Hogarth's career. He could console himself with having already achieved fame and a measure of prosperity by efforts of another kind. But his animus against the 'phizmongers' was all the stronger. When 'the tailor', as Van Aken was known, died in 1749, Hogarth

caricatured the group of fashionable portrait painters who had depended on him bewailing his demise. An especial venom assailed the 'exotics', as Hogarth termed the foreign portrait painters who, he said, with a good deal of exaggeration, 'by the assistance of puffing, monopolized all the people of fashion'. There were in fact portrait commissions enough to keep both natives and foreigners busy, though the latter certainly had their share.

George II doted on the German enameller and miniaturist, Frederick Zincke, who had the flattering capacity for making the King and Queen, when well advanced in years, look not more than twenty-five. Favoured in the 1730s were the Florentine, Andrea Soldi, and the French painter, Jean-Baptiste van Loo, brother of the history painter, Carle van Loo. Jean-Baptiste was a much-travelled man who had painted King Stanislas of Poland and was favoured in England by Sir Robert Walpole and the aristocratic circles in which the Earl of Burlington moved. He caused an outcry by his eclipse of English rivals, though it would be too much to say with Hogarth that he spread ruin among them. At all events the Scottish portrait painter, Allan Ramsay, who started a London career with a great éclat in 1738, was soon able to boast, 'I have put all your Vanlois and Soldis and Roscos [i.e. Rusca, a visiting Milanese painter] to flight and now play the first fiddle myself.' Van Loo, to the general relief of the profession, was otherwise put to flight by those typical ailments of the century, gout and dropsy, after some years leaving England for the more propitious climate of his native Provence.

Allan Ramsay could not, any more than others, escape the charge of phizmongering. It was part of the indictment against him not only that he employed the drapery man, Van Aken, but had studied abroad in France and Italy and introduced alien refinements in consequence. He was criticized, by Vertue as well as Hogarth, for what the latter called 'painting faces all red, all blue, all purple'. This caricatured Ramsay's practice of working over a vermilion underpainting that in fact gave an added value of underlying warmth to the cooler face colours. Ramsay – 'Ram's eye' as Hogarth chose to parody his name – also aroused his prejudice by venturing to question whether Hogarth could paint as good a portrait as Van Dyck.

Bias was unfairly exercised against Ramsay's exquisite art, in

which he was one of the century's outstanding British masters. But on the whole the list of face painters in the first half of the eighteenth century was hardly inspiring. A French observer, the Abbé Le Blanc, in England between 1737 and 1744, is quoted as a critic even more severe than Hogarth. In his view portrait painters were never more numerous – or worse. Many, it is true, have become too obscure for even their demerits to be called into question – men such as Hans Huyssing, a Swedish immigrant, Isaac Wood employed by the Dukes of Bedford, Jeremiah Davison, Hamlet Winstanley, the teacher of George Stubbs, Robinson of Bath, who had a temporary vogue for portraits in Van Dyck costume, and others to whom the tireless pen of Vertue attached some fleeting note. The names of Jonathan Richardson, father and son, painters and in collaboration writers; Thomas Hudson, who had Joshua Reynolds for pupil; and George Knapton, who portrayed the members of the Society of Virtuosi, are of rather more consequence for their 'honest similitudes', to use the phrase Horace Walpole applied to Hudson, if still below the level of the great age of Reynolds and Gainsborough to come. But portraiture in Hogarth's time took an original form in the 'conversation piece' in which he himself excelled.

To paint a family group or a group of familiars engaged in their usual occupations or amusements was not exactly a new idea. Dutch and Flemish artists of an earlier day had painted their small, intimate pictures of family life. In England the conversation piece was new to the extent of becoming distinctively national and in the variety of uses to which it lent itself. It suggested the domestic scene primarily but was capable of branching out to depict the open-air occasions of sport, the related figures of a stage play, the characters of a contemporary novel.

In picturing the upper levels of early Georgian society, the conversation piece had its special attractions for the client and its advantages for the painter. That section of the nobility and gentry with no special wish to be invested with the imposing formality of the large-scale individual portrait and a merchant class grown wealthy in whom the appearance of grandeur would have been out of place, could equally take pleasure in the reflection of family ties and friendships, sometimes of the 'assemblies' that brought employers and servants together in the democratic enjoyment of music and dance. There was the satisfaction too to be derived

from the record of possessions detailed in a well-ordered interior or, in the open, the glimpse of cultivated ground that made a fit setting for its proprietors.

In a parallel way, the artist was relieved of a number of the problems besetting the face-painter. He had more licence in devising a composition, could dwell on the variations of everyday dress instead of stiffly ceremonial array, could apply himself to the still-life objects his patrons valued, their furniture, carpets and picture collections, could introduce movement with a freedom that copying the pose of a single sitter did not allow.

National in development in the reign of George II, the genre owed something to France. No insular declaimer against foreigners could prevent a contact of this kind, through the medium of French artists who settled in England, as well as the engravings that circulated in both countries. One channel of communication was Philip Mercier, among the first to start the conversation piece on its course and from it to evolve the 'fancy picture', the domestic scene with imagined characters. Mercier, the son of a Huguenot tapestry worker in Berlin, studied art there under a French painter, Antoine Pesne, and according to Vertue travelled to Italy, then through France, whence he came to England about the year 1716. He was greatly influenced by Watteau and it has been surmised that he was Watteau's host when the ailing French master came to London in 1719 to consult Dr Mead, the visit that otherwise passed without notice. A little of Watteau's own evolution can be traced in Mercier. He began with direct imitations and engraved copies after Watteau's poetic visions of aristocratic entertainment – the *fêtes galantes*, embarkations and departures to and from the dream island, Cythera, of courtly love. Yet as the greater artist could balance the fanciful theme with the grasp of reality so superbly displayed in his shop-sign for the dealer Gersaint, so Mercier in the course of the 1720s, as he became acclimatized to England, was diverted from Cythera to the English country house and the portrayal of its assembled families and friends.

What Horace Walpole called Mercier's 'genteel style of his own with a little of Watteau' appealed to George II's son, the art-loving Frederick, Prince of Wales, who appointed him his Principal Painter, a position Mercier kept for some years. The Prince's fondness for music is conveyed in the artist's delicately painted

variants of Frederick's performance on the bass viol, accompanied
by Anne, the Princess Royal, on the harpsichord and Princess
Caroline on the form of lute known as the mandora, the third
sister, Amelia, giving her attention the while to the poems of
Milton.

After leaving the Prince's employment in 1735, Mercier travelled
to York, a centre of fashion, like Bath and Dublin, alternative to
London, embellished in addition to its medieval monuments by
so classically modern a building as the Assembly Rooms com-
pleted in 1732 to Lord Burlington's design. In a twelve-year stay,
during which Mercier found 'much imployments of Nobility and
Gentry' he produced both portraits and the 'fancy' pictures of
domestic life in which a distant memory of Chardin as well as
Watteau can be discerned.

Another artist who transplanted at least the idea of the *fête
galante*, though with his own peculiarities of style, was Marcellus
Laroon the Younger, whose father had been one of Kneller's
assistants. After his many adventures – as an actor at Drury Lane,
a singer, a guide to travellers abroad, a soldier in Marlborough's
army, the younger Marcellus, when a half-pay captain, spent much
of his time in painting fashionable strollers, receptions and musical
parties, 'conversations well-designed' Vertue was bound to admit
in spite of his dislike of Laroon's conceit and the callousness with
which he laughed 'upon some occasions at the death of his dearest
friends'.

Laroon's unconventional method of outlining his thinly painted
figures with thick contours placed him some distance, in an
imagined social world, from those who employed the conversa-
tion piece for the closer observation of reality. A number of the
latter were associated with the St Martin's Lane Academy. They
included Joseph Highmore, who apart from the methods of
attracting important sitters that Vertue deprecated (as he did in
so many other portrait painters) and what Vertue described as the
'modish assurance' of individual portraits, was well able to com-
pose a group in a simple and natural manner.

A rare example of his conversation pieces is *Mr Oldham and his
Friends* in such a jovial meeting over pipe and bowl as the Georg-
ians delighted in. The occasion was informal, the participants
Nathaniel Oldham, a wealthy collector and property owner at his
house in Ealing, with a local schoolmaster and farmer and the

artist himself. An elegant type of composition is to be found in Highmore's interpretation of Samuel Richardson's novels, *Pamela* and *Clarissa*. Like Hogarth he set his characters as if on a stage, though there comparison between the two artists comes to an end. It is an indication of how little for a long time Hogarth's contemporaries were individually studied that *Mr Oldham and his Friends* and Highmore's painting of the Harlowe family, from *Clarissa*, were both attributed to Hogarth in spite of differences that now seem plain to view.

The twelve illustrations to *Pamela* gave an accurate description of male and female costume in the 1740s, though the characters, unlike those of the greater artist, moved like so many dolls of fixed expression in obedience to the elaborate system of conduct that Richardson prescribed. They represented society at a remove, after its filtration through the channels of morality and virtue, pursued at intricate length by the novelist. The grace of style has some affinity with that of a fellow member of the St Martin's Lane Academy, Hubert Gravelot. A certain primness otherwise reflects the way in which Highmore caught the spirit of the work he illustrated, a sympathy no doubt proceeding from the likeness of mind that made artist and writer lifelong friends.

Gravelot, whose real name was Hubert François Bourguignon, Parisian-born and a pupil of Boucher, was a French 'little master' ('little' in the sense of working on a small scale), expert in ornamental design and the lightly treated 'fancy' subject that was an offshoot of the conversation piece. Coming to London in 1732 he stayed for thirteen years, amassing a comfortable fortune by his unremitting industry. He had his own drawing school at the sign of the Pestle and Mortar in James Street, Covent Garden, and frequented the favourite rendezvous of artists, Old Slaughter's Coffee House in St Martin's Lane, along with Francis Hayman, Hogarth and others. Hayman in particular was impressed by the rococo elegance of Gravelot's work, an object lesson in refinement that modified insular roughness. Hayman's open-air conversation pieces with small full-length figures in a landscape setting were a departure that the young Gainsborough was to carry to a splendid fruition.

The practitioners of the conversation piece in the first half of the eighteenth century were many. From Mercier to Arthur Devis in mid-century, naïvely and entertainingly precise in his delinea-

tion of provincial society, they retrieved art from the boredom of phizmongering, with delightful individualities of manner and an outlook refreshed by the nature of their subjects. Pre-eminent among them was Hogarth. By 1729 Vertue could remark on 'the daily success of Mr Hogarth in painting small family pictures'. He outshone such rivals and imitators as the Scottish painter, Gawen Hamilton, of whom Vertue wrote with approval, 'He may well be esteemed a rival to Hogarth, having as much justness if not so much fire'; Charles Philips, whose conversation pieces 'met with great encouragement amongst people of fashion even some of ye Royal Family'; Bartholomew Dandridge, who departed from the tradition of Kneller in small groups of rococo charm.

In his politest vein Hogarth came as near to an amicable relation with 'high society' as he was ever to get. If the court circle was closed to him there were families of no small distinction in title, wealth or position who looked with favour on his abilities, not least because of the sympathetic understanding of the young that he always displayed. The aristocratic children enacting a scene from Dryden's *The Indian Emperor or The Conquest of Mexico* in the masterly group he painted in 1731 for John Conduitt, Master to the Mint, play their grown-up parts with the captivating gravity of ten-year-olds. The small son of Viscount Malpas and his wife, Mary, the daughter of Sir Robert Walpole, in the family group painted in 1732, have all the vivacity and spring of movement that Hogarth better than any could convey. The feeling of these early groups is renewed in the larger-scale masterpieces of his middle years. He enters into the gleeful spirit of the children of Daniel Graham, apothecary to Chelsea Hospital, as they listen to the tune of a musical box, the marvellous cat, tense on the back of a chair, one of the most memorable felines of art, adding its quota to the excitement. In *The Mackinnon Children* of about the same date, *c.* 1742, the boy's intentness on the butterfly he is poised to capture vividly preludes the picture Gainsborough was later to paint of his daughters in similar pursuit.

An instance of the decorous fashion in which Hogarth in the 1740s could depict the placid surface of well-bred existence is his painting of the Strode family at breakfast. William Strode, Member of Parliament for Reading, beautifully tailored but with the abstention from fancy proper to a rising politician, invites a clerical friend, Dr Arthur Smyth (later Archbishop of Dublin),

prayer-book in hand, to take a dish of tea. Lady Anne Strode, daughter of the Earl of Salisbury, sits beside her brother-in-law, Samuel Strode in the ceremonial panoply of his long blue coat with gilt facings. The dignified propriety of the group is reflected in the refinement of taste that has its evidence in the breakfast silver, the background of books appropriate to a gentleman's library, the paintings so symmetrically hung with a Salvator Rosa-like landscape (or possibly a Marco Ricci) prominently in view.

There is a shock of contrast in realizing how far, by the time this picture of domestic well-being was painted, Hogarth had progressed in other and very different directions. The two great series *A Harlot's Progress, A Rake's Progress* had delighted the town. About the time he portrayed the Strode family he was engaged on the marital situation remote from their domestic contentment, *Marriage à la Mode*. He had refused to confine himself to the conversation piece, suspecting it might turn into a mechanical drudgery no better than phizmongering. Beneath the cultured surface or apart from it was the reality of Georgian life in all its imperfections – for a painter of original mind a rich source of material untapped.

Behind the Polite Façade

The social observer could find in the reign of George II much to oppose to the polite and presumably serene nature of the élite devoted to the idealisms of culture, of whom Lord Burlington was so eminently the model; to the edifying spectacle of the well-behaved families the conversation painters provided. It was a time of hearty materialism when the populace ate and drank – and especially drank – with uninhibited zest. Roast beef and beer in popular esteem were not only the symbols of good living but, albeit somewhat mysteriously, of national virtues.

Of many jolly effusions of tavern-bred democracy, a sample, as it were deliberately plebeian, is afforded by Hogarth himself and a company of friends in that celebrated outing, the authentic and jocular manuscript account of which is preserved in the British Library, the *Five Days' Peregrination* in May, 1732. It is significant who the friends were, none of course of the portrait men so often angered by his pretensions and outspoken criticisms or possible patrons of the superior kind, but a miscellaneous collection of middle-class intimates in various walks of life.

The artists were Samuel Scott, another 'five-foot man' (or even just under) whose seascapes and views of the London Thames were a specialization so far removed from Hogarth's own as to preclude rivalry; and John Thornhill, the son of Sir James, who though he succeeded his father as Sergeant-Painter was more inclined to settle, as he eventually did, as a country gentleman on the family estate in Dorset. The others, neighbours in the Covent Garden area, were an enterprising draper with a successful sideline in selling rum and brandy, William Tothall; and a lawyer who also wrote some satirical pieces for the theatre, Ebenezer Forrest.

What rounds of porter at the Bedford Arms, Covent Garden, at the corner of the Little Piazza facing St Paul's Church, preceded the sudden decision to set out at once for the coast of Kent, can only be imagined. What the wives thought when briefly notified history does not relate – perhaps they were sufficiently inured to such not uncommon freaks of masculine behaviour as to raise no demur. In the mind's eye one can see a somewhat unsteady procession down the riverside at midnight, chorusing the refrain of 'Why should we quarrel for riches', en route to take boat at Billingsgate and thence to 'adventure'. It was a comical adventure, later turned into Hudibrastic verse by the Kentish antiquary, William Gostling, taking them no farther than Rochester and Chatham, across the Medway to Sheerness, Queenborough and Minster in the Isle of Sheppey and home by way of the Water Gate behind Somerset House. There was comedy in its being a Cockney parody of the nobleman's Grand Tour, perhaps also a joke at the expense of the growing taste for antiquarian expeditions. Hogarth's drawings for the manuscript added a tang of pictorial satire in his frontispiece of an empty 'Mr Somebody' amid the ruins of the past and of democratic challenge in the 'Mr Nobody' of the tailpiece, intimating his contempt for learned pretentiousness and dedication to no one in particular, i.e. the general public. Otherwise unpolemic, the expedition was a cheerful affair in the course of which hearty appetites did justice to such a dinner as they had at Rochester. Lasting from one o'clock until three, consisting of 'a Dish of Soles and Flounders with Crab Sauce, a Calves heart Stuff'd and Roasted, ye Liver Fry'd and the other appurtenances Minc'd, a Leg of Mutton Roasted and Some Green Pease ... with Good Small beer and excellent Port'.

The *bonhomie* of the Peregrinators, like the mild-seeming entertainment of Highmore's Mr Oldham and his local cronies with their churchwarden pipes and glasses of negus, is in contrast with indulgence of a less moderate kind. There is Hogarth's testimony, as observer rather than participant, to the orgiastic element in the age, the point where joviality turned into frenzy. In the *Midnight Modern Conversation* of 1731 he pictured the wild drunkenness of all-male gatherings, their members reeling, wigs awry, falling stupefied to the floor, nodding in fuddled slumber, sick with their potations. The engraving from the picture disclaimed any reference to actual persons, though efforts made by others to identify

them suggest a socially mixed assembly, including a parson, a tobacconist, a barrister and a bookbinder.

The habit of carousal was not confined to such miscellaneous congregations of revellers but extended to aristocratic and learned levels. The meetings of the Society of Dilettanti, formed in the 1730s for the furtherance of antiquarian pursuits, were sarcastically described by Horace Walpole as 'an excuse to drink'. It pleased Lord Boyne, one of the Society's promoters, to commission from Hogarth such scenes of aristocratic revelry as that of an intoxicated group in a cellar consuming a hogshead of claret or entangled with the watch as they staggered out of a tavern into the dangerous darkness of the street.

That drunkenness should so often have been Hogarth's theme, to be further studied in the foolishness of Tom Rakewell in *A Rake's Progress*, the tipsy soldiery of the *March to Finchley*, the boisterous behaviour of the company in the *Election Entertainment* and the besotted wrecks of *Gin Lane*, might need some explanation beyond the simple statement that a picture of early Georgian society could scarcely avoid taking notice of so prevalent a form of indulgence. But what an opportunity it also gave to a master of expression to study the natural human being stripped of the masks of convention, to take note of movement and gesture in undisciplined freedom.

The natural animal, stripped of disguises and accused not merely of frivolity but of offences against organized society, offered to the clinical eye another field of study. The picture of society was not complete without its outcasts, enemies and prisoners. A curiosity as to what they looked like and how they acted impelled none other that Sir James Thornhill in company with his young associate, William Hogarth, to visit Newgate Gaol in 1724 and draw the notorious Jack Sheppard in the condemned cell.

Theirs was a grim research. Forbidding in itself the once gatehouse prison had of old been the fifth principal gate in the City wall. More massive when the two artists surveyed it than the earlier prison building destroyed in the Great Fire of 1666, it was curiously adorned with statuary, the figures of Justice, Mercy and Truth on the City side and on the west, Liberty (attended by Whittington's cat), Peace, Plenty and Concord. In sinister contrast were the narrow cells, each with grated window, barrack bed and door four inches thick. The convicted who put on a bold front at

their trial were often known to collapse in horror when brought
to these pits of lonely gloom.

More sinister still than the Fleet prison of which Hogarth had
had his early experience, Newgate was the scene of tortures in-
herited from the medieval past, the thumbscrew and the *peine forte
et dure* by which the prisoner who refused to plead was pressed
under weights of iron and stone. Over all hung the nauseous taint
of unsanitary conditions that caused recurrent epidemics of what
was known as 'gaol fever'. In 1750 the virulent infection was to
spread to the neighbouring Old Bailey where many prisoners
awaiting trial were cooped up in two small rooms. No respecter of
persons, the fever on this occasion caused the death of the judge
and several barristers and jurymen.

Those who incurred the penalties of Newgate were remarkably
various, from the mildest of offenders to those deeply involved
in crime. The calendar comprised traitors, murderers, incendiaries,
ravishers, pirates, mutineers, coiners, highwaymen, footpads,
housebreakers, rioters, extortioners, sharpers, forgers, pick-
pockets, fraudulent bankrupts and thieves of every description.
There were degrees of prestige attaching to these categories.
Public esteem favoured those who followed the supposedly
gentleman-like occupation of highwayman and others distin-
guished by acts of reckless daring. Their engraved portraits were
more widely known and eagerly scrutinized than those of respect-
able grandees. No doubt this consideration too had its weight
with Thornhill, diverted for the moment from the abstractions of
allegory and symbol to Jack Sheppard's highly individual fame.

As a thief he was perhaps of little account but as an escapist in
a class by himself, famous enough to be the subject of many a
popular broadsheet and history and of stage performances also.
He was the subject of a Drury Lane pantomime, *Harlequin
Sheppard*, the hero of a farce in three acts entitled *The Prison Breaker*.
Born in Spitalfields in 1702 he began as a thief in a small way when
a carpenter's apprentice, sharing the proceeds with a woman fence
known as 'Edgworth Bess'. He rose to eminence by the unique
facility with which he broke out of prison. His greatest exploit
was his escape from Newgate after being condemned to death for
robbing a draper's shop. Every precaution was taken to guard
against his already well-known skill. He was put in the strong
room called 'the Castle', handcuffed and chained in leg irons to a

staple driven into the floor. Somehow he contrived to slip out of
the handcuffs, tear out the staple, still in leg irons climb up the
chimney of the heavily barred and bolted 'Castle', cross over
roofs and thence down a staircase into the street. He persuaded a
locksmith to free him of his fetters and in newly bought finery
strutted boldly in his old haunts until in drunken glory he was
recaptured and sentenced to execution at Tyburn.

Thornhill portrayed him when he awaited the final triumph of
the procession to Tyburn accompanied by the cheering mob that
always gathered for such occasions, a young man only in his
twenty-third year with close-cropped hair and sharp Cockney
features. The painting was promptly engraved in mezzotint and
lauded in verse:

> Thornhill, 'tis thine to gild with fame
> Th' obscure and raise the humble one:
> To make this form elude the grave,
> And Sheppard from oblivion save.

Humanity, defiant, out of the normal and in condition of stress
made an impression on Hogarth that led him to other portraits of
the individual condemned. He and Thornhill again went to
Newgate in order to see the convicted murderess, Sarah Malcolm,
two days before her execution. She was one of the 'laundresses'
in the Temple who looked after the sets of chambers of members
of the legal profession and other apartments rented to private
tenants. The latter included an old lady of eighty, Mrs Lydia
Duncombe, reputed to be wealthy, who lived in the Temple with
her two servants. All three were found dead, Mrs Duncombe and
the elder servant strangled, the younger servant with her throat cut.

The laundress, discovered to be in possession of property
belonging to the old lady, admitted the robbery but denied the
murder, blaming for this the bad companions she had fallen in
with at the Black Horse public house near Temple Bar. In spite
of this her guilt was held to be beyond doubt. Her features, in
Hogarth's view as recorded in a remark to Thornhill, proclaimed
her 'capable of any wickedness'. This is not so obvious in the
portrait itself unless it lay in a certain hardness of expression in
the young woman, just over twenty-one, who was executed oppo-
site Mitre Court in Fleet Street in 1733. The circumstances gave
the portrait a wide sale in the form of a popular print.

Many years later Hogarth was again to display this clinical interest in the character and attitude of the individual imprisoned and condemned when he portrayed Simon, Lord Lovat brought south for trial and sentenced with other leaders of the attempted rebellion of 1745 after the crushing defeat of Culloden. He was not one who could be regarded as the hero or martyr of a national rising but rather, in Lord Belhaven's words, as 'a proteus apostate, backwards and forwards'. Outlawed, and after brutally forcing the dowager Lady Lovat into marriage, he had fled to France and entered into league with James Stuart, the 'Old Pretender', though at the instance of the British ambassador he was arrested and imprisoned in the Bastille. Turning Catholic, he gained his liberty by becoming a Jesuit priest. In the first rising on the Stuart behalf in 1715 he joined the Hanoverian forces and in reward was confirmed in the title of Lord Lovat, but in the '45 he again changed sides and joined Charles Edward, the 'Young Pretender'.

When Hogarth saw him at the White Hart in St Albans on Lovat's way south as captive, he was eighty, tall but corpulent, made unwieldy of figure by the number of garments he wore one over the other, deaf and short-sighted but otherwise well-preserved. Unforgettable was the rendering of his sly smile, the habit of calculation suggested by the way he weighed up the odds of battle on the tips of his fingers.

Newgate at all times was a Dantesque portal through which to peer down into the abyss of London's underworld whence the unfortunate had no means of escape, where ferocious beings preyed both on society and each other, where fame and infamy were strangely confused. The idea of the gallant and chivalrous gentleman-highwayman was a myth that did not bear close inquiry. The Dick Turpin of romantic legend, executed at York in 1739, was the leader of a gang capable of roasting an old woman over a fire until she disclosed where her little hoard of money was hidden. Horace Walpole might airily say of his encounter with the highwayman James Maclean in Hyde Park that 'the whole affair was conducted with the greatest good-breeding on both sides', but he narrowly escaped being shot and was afterwards pursued by threats unpleasant enough.

Law and lawlessness could be as inextricably confused as in the career of the 'Prince of Robbers', Jonathan Wild. Head of a whole corporation of thieves, he also acted as thief-taker and informer

against those who did not carry out his orders in his role as criminal in chief. Before his execution at Tyburn he spoke with consummate hypocrisy of the services he had rendered the public in returning stolen goods to their owners and apprehending felons.

It was left to Henry Fielding in the 1740s to trace his progress with unrelenting sarcasm in the *History of Jonathan Wild the Great*. The theatre had already brought the underworld into dramatic focus in *The Beggar's Opera*, first produced in 1728, a departure among stage performances that also marks a turning point in Hogarth's career as a painter.

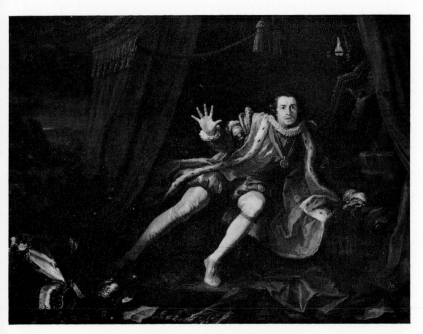

13 *Garrick as Richard III, c.* 1745
14 *Marriage à la Mode,* 1743–5. Scene VI, 'The Suicide of the Countess'

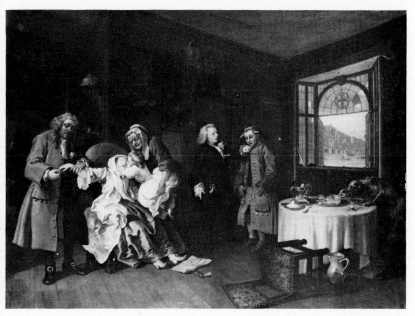

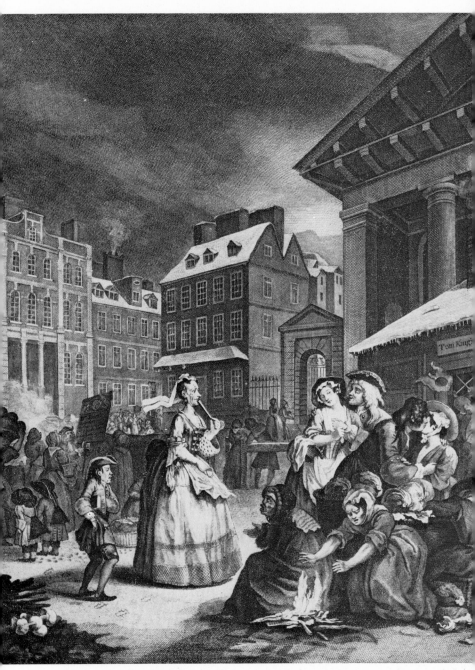

15 *The Four Times of Day*, 'Morning', *c.* 1736

Newgate Pastoral

The spirit of satire was as lively when George II came to the throne as in Dryden's time, though since then its form and purposes had varied. Mild reproof, a polite chiding designed for the general betterment of manners had been its character in the Augustan moderation of Joseph Addison and the *Spectator* essays. Pope's *The Dunciad*, first appearing in 1728, reverted to Dryden's practice of hurling Jovian bolts at literary and other personal enemies. Less concerned with trivialities, with a deadly precision of aim at targets of wider concern, was the man whom Addison had termed 'the greatest genius of the nation', Jonathan Swift.

Swift's acrid pen, in the *Drapier's Letters* of 1724, exposed the scandal of a watered-down Irish currency. Irony reached a peak in the pretended argument for cannibalism of the *Modest Proposal as to the Children of the Irish Poor* that shocked even those who did not believe him to be serious. A comprehensive pessimism and contempt for humanity was implicit in the fantasy of *Gulliver's Travels*, 1726, the brutal Yahoos, the senile Struldbrugs, the absurd scientists of Laputa. The delight in ferocities of paradox and the reversal of accepted proportions prompted the suggestion of a 'Newgate pastoral' with thieves and highwaymen as its heroes. Exploring the possibilities, Swift had toyed with the idea, in a letter to Pope, of 'a porter, chairman or footman's pastoral ... Or what think you of a Newgate pastoral?'

Good-humoured, unpractical, indolent, John Gay was once again spurred on to write by his friends of the 'Scriblerus Club'. Swift had already provided hints for Gay's *Trivia, or the Art of Walking the Streets of London* with its advice on how 'to walk un-harm'd the dangerous night' in the ill-lit metropolis. The idea of

E

the 'Newgate Pastoral' of which Gay was now made a present, turned into *The Beggar's Opera*, a tremendous and unexpected success from its first production at the Theatre Royal in Lincoln's Inn Fields under the auspices of the theatre manager, John Rich.

The success was due in part to its topical matter. The types portrayed with a cynical frivolity to which Swift may have made some contribution were instantly recognizable. Peachum, the informer who 'acts in a double capacity, both against rogues and for 'em', recalls Jonathan Wild. Easy to identify in real life were Peachum's rival, the gaoler, Lockit and the swaggering Captain Macheath. The contenders for his affections, Polly Peachum and Lucy Lockit, parodied the ladies who wept at the trial of some handsome 'gentleman-highwayman'. Enjoyable to a Georgian audience was the covert reference assumed in the rivalry of the guardians of the law to the breach between Sir Robert Walpole and Charles Townshend. Especially popular was the young actress who took the part of Polly, Lavinia Fenton, a girl of fifteen, previously employed by Rich at a small wage in obscure roles. With her lament for Macheath's threatened fate:

> For on the rope that hangs my dear
> Depends poor Polly's life.

she became at once the 'favourite of the town'.

An additional reason for the opera's popularity was the charm of old songs and tunes, culled from various sources and refurbished, after the style of the poet Allan Ramsay's *The Gentle Shepherd*. The simple native airs were the very opposite of the elaborations of Italian opera that Handel had brought to London. They caused a reaction against the sophisticated performances of imported musicians. Many theatregoers found the spectacle of native villainy more entertaining than the heroics of classical opera. If not as deliberately intended an attack on that aspect of Lord Burlington's patronage as Hogarth's satirical sallies, *The Beggar's Opera* was effective enough, at least for a time, to drive Italian opera from the stage.

One grand operatic venture after another failed: the Royal Academy of Music that Burlington had helped to finance, in 1728; a new company formed with the approval of George II; a third, the 'Opera of the Nobility' supported by Frederick, Prince of Wales in opposition to his father whom he loved to annoy.

Meanwhile *The Beggar's Opera* went on from triumph to triumph in London, in Bath, in Bristol, in Dublin and even as far abroad as Minorca.

Gay thus contributed to bring one of Burlington's cherished schemes to nothing, an untoward result seeing he had been allowed to lodge at Burlington House for fifteen years, had referred with poetic rapture in *Trivia* to 'Burlington's fair palace', and included a eulogy on Handel whose 'melting strain / Transports the soul and thrills thro' every vein'. Hogarth could be accused of no such turncoat behaviour. The Newgate Pastoral was entirely in line with his earlier attacks on 'Taste' and his attitude to foreign imports in the guise of a superior culture. Fruitful in result for him as for its author, *The Beggar's Opera* provided a series of commissions, congenial subjects and a stimulus to his development as an artist. In a short space of time he produced six painted versions of the scene that lent itself most aptly to pictorial treatment as well as topical burlesque in prints.

The chosen scene (Act III, Scene XI) was that where Lucy and Polly, on either side of the manacled highwayman, plead for his life with their parents, who have their own interest in seeing him hanged. Included also were the favoured spectators still allowed their place at close quarters with the performers on the Georgian stage. Beside the producer and author were a number of persons of title, among them the Duke of Bolton (whom Swift disrespectfully called 'that great booby'), whose mistress Lavinia Fenton became and after many years his Duchess. An envoi to the pictorial sequence was her portrait by Hogarth, *c.* 1740, still with a trace of 'Pollyhood' (Horace Walpole's word) about her large and lustrous eyes.

The group composition, as first seen at the Lincoln's Inn Fields theatre, was improved by the artist as he went along. A final version gave increased dramatic point to the gestures of the players. The prison setting became more spacious, with an anticipation of the larger stage of the Drury Lane Theatre that Rich moved to in 1732. The heavy folds of curtains, the modelled satyrs in the wings derisively framed the prison interior with baroque grandeur, the sparkling colour of costume against the stony background matched the poet's flippancy. Otherwise there was no occasion to add to the satire implicit in the whole situation. Gay and Hogarth never seem to have been personally acquainted, nor did *Polly*, the

sequel to *The Beggar's Opera* on which the poet promptly set to work, offer the opportunity of similar treatment to the artist. *Polly*, banned by the Lord Chamberlain, at the instance, it was understood, of Sir Robert Walpole, was not produced on the stage until 1777, though its more open criticism of politics and politicians made it popular in printed form. In the setting, transferred from Newgate to the West Indies, the contrast was made between the honest native and the European full of duplicity, the more unwelcome in official quarters from the assumption that the unscrupulous Morano, the villain of the piece, represented Walpole himself.

For Hogarth, *The Beggar's Opera* was enough to suggest that the painter could be a dramatist of a sort in his own right. 'My picture is my stage and men and women my players who by means of certain gestures and actions exhibit a dumb show', was the conclusion he arrived at. It was possible to apply the stage technique to the life of the time in general, not only the polite domestic stage of the conversation piece but the wider arena of London life in all its splendours and miseries. When Gay died in 1732, after disappointment, long illness and retirement to the haven offered by his partisans the Duke and Duchess of Queensberry, Hogarth was impelled by the current of his ideas towards greater achievement in depicting the whole 'Human Comedy'.

For drama of any kind a plot was essential. The playwright could evolve it over a period of time in the sequence of acts and scenes. The visual artist committed to a plot, a beginning, middle and end, inevitably followed suit as far as the conditions of his own art allowed, not in one but in a series of developing situations. Paintings in series were not entirely without European precedent. By this means Murillo had dramatically presented the history of the Prodigal Son. Hogarth's inventive powers, in one series after another, set society in motion in a way that was new to art.

~~ 12 ~~

'*Modern Moral Subjects*'

George Vertue, ever observant, followed and recorded the steps by which the new idea took shape. He described in his notebook for 1732 how Hogarth began 'a small picture of a common harlot, supposed to dwell in drewry lane, just riseing about noon out of bed and at breakfast a bunter [i.e. a vulgar type of female] waiting on her'. The picture took the fancy of those who saw it. Some asked for a companion piece, 'then other thoughts increased and multiplied by his fruitful invention till he made six different subjects which he painted so naturally the thoughts strikeing the expressions, that it drew everybody to see them'. Thus *A Harlot's Progress* came into being.

The subject was no novelty in the literature of the early eighteenth century, though how the story should end had equivocal answers. Ten years before Daniel Defoe had written *The Fortunes and Misfortunes of Moll Flanders*, 'Twelve year a Whore, Five Times a Wife (whereof once to her own brother), Twelve Year a Thief, Eight Year a Transported Felon in Virginia'. Her narrative omitted no detail of wrongdoing but Defoe had allowed her to return to England with her last husband, 'after all the fatigues and all the miseries we have both gone through ... in good heart and health'. Though tempered by some words of 'sincere penitence', this was a surprisingly cheerful conclusion to a story of delinquency. Gay, through the medium of his 'Beggar', relented at last to reprieve Macheath from the condemned cell and save the complement of rogues and whores from hanging or transportation on the ground that all was in jest and with the remark that 'an opera must end happily'. The happy endings of the novel without a plot and the opera with an indulgent measure of fantasy, were

not, either aesthetically or morally, in keeping with Hogarth's intentions. If 'comedy' in an exact definition implied a happy ending, his business, it could be said, was with its opposite. The descent into the depths which it became his function to depict, through all the layers of London life, could only be edifying if it ended miserably. That it did often so end, if not invariably in real life, there was evidence enough in the annals of Newgate, Bridewell and Bedlam. The central characters of Hogarth's pictured stories were less than tragic if the word be taken to imply the individual with remarkable endowments brought to nothing by some fatal flaw. As the puppets of fate, not in themselves remarkable, they enabled the artist to bring into view all the forces that shaped their hapless lives.

It was not possible for Hogarth to approach the subject of sex in any but a serious mood. Before he came to detail the adventures and tribulations of Moll Hackabout in *A Harlot's Progress* he essayed the kind of amorous scene that the French painters and engravers were able to invest with a smiling charm. Their delicate eroticism was not for him. His pictures of a seduction, *Before* and *After*, show his temperamental unfitness for the *sujet galant*, such for example as his contemporary in France, Pierre Baudouin, devised with every circumstance of luxury and arch allusiveness. Realism routed Eros. Hogarth would probably have agreed with Diderot that Baudoin's 'gallantry' was lascivious and disingenuous. The description would little apply to *Before* and *After* where the strain of the situation is more apparent than the pleasure involved. The air of guilty embarrassment in which the episode terminated might almost be called a moral in itself.

Conventionally moral in outline was the story of Moll Hackabout in *A Harlot's Progress*, but the engraved series was popular on other counts: the topicality that introduced known characters, the variety of person, incident and place, and what Charles Lamb called 'the dumb rhetoric of the scenery', the way in which inanimate objects in lieu of the minor players of the stage became living things in their silent comment on the action going forward.

Readily identifiable in the opening scene of *A Harlot's Progress* was the unprepossessing personality of Francis Charteris, described in the most scathing of epitaphs, by Dr Arbuthnot, as one 'Who with an inflexible constancy and inimitable uniformity of life persisted in spite of age and infirmity in the practice of every

human vice, excepting Prodigality and Hypocrisy. His insatiable Avarice exempted him from the first, his matchless Impudence from the second'.

Charteris had grown rich through gambling and usury. As a cornet of dragoons in Marlborough's army he had used the tricks of the card-sharp to strip his fellow officers of their money, which he lent back to them at an exorbitant rate of interest. Tried by court-martial after numerous complaints, he was forced to disgorge the sums he had acquired and was drummed out of his regiment. Going to Scotland he contrived to get another army commission. He resumed his manipulation of cards and managed to win £3,000 from the Duchess of Queensberry. In London he preyed on women and the compilers of the *Newgate Calendar* relate how he kept in pay 'women of abandoned character who going to inns where the country wagons put up used to prevail on harmless young girls to go to the colonel's house as servants; the consequence of which was that their ruin soon followed ... '

Charged with rape in 1730, he was consigned to Newgate, tried at the Old Bailey, found guilty and sentenced to execution. But the law, so harsh on the penniless and the minor offender, was considerate to the wealthy rogue, not only rich but well-connected by the marriage of his daughter to the Earl of Wemyss. Charteris was pardoned and retired to Edinburgh, though in such bad odour that when he died soon after, an angry mob threatened to tear him from his coffin and threw dead dogs and offal into his grave.

One of his go-betweens was another notorious character, 'Mother' Needham, who kept a bawdy house in Park Place, off St James's Street, sarcastically described by Pope in *The Dunciad* as 'pious'. She died after being twice exposed in the pillory to the jeers and pelted rubbish of the populace. The scene of the country-girl's arrival in London, at once the object of predatory eyes, was ready-made for Hogarth when he painted and began to engrave his series in 1732. It was Charteris he pictured on the steps of the Bell Inn in Wood Street in the City, with its chequered front denoting that it sold spirits, an ungainly figure with a lubricious look. It was the 'pious' Mother Needham, patched and powdered, who chucks the girl under the chin with a wicked smirk of appraisal.

The pictorial story-teller's gift invests every detail with meaning.

Lettering adds explanation where it seemed called for. The girl's father has convoyed the country wagon from Yorkshire, the wording on its cover informs us. A short-sighted old parson, he peers at the address on his letter of introduction to the bishop. A goose, present from the country, is labelled 'to my loving Cosens in Tems Street in London'. The initials M.H. on the trunk are those of the suggestive name the artist has found for the girl. The method at once established, combining topical reference with a wealth of clues to elucidate the action, was consistently pursued in the five episodes to follow.

The settings had always their tale to tell. In the second episode where the now calloused Moll Hackabout is seen as a kept woman, creating a diversion by upsetting a table to allow a lover to escape undetected by her Jewish protector, the interior is rich and heavy. Old Testament pictures, *The Prophet Jonah facing the city of Nineveh*, *King David dancing before the Ark of the Covenant*, are sombre against an ornate wallpaper. Stark in contrast is the lodging in Drury Lane to which she has come down in the next scene, shared, it is to be gathered, from the wigbox over the bed, with the thief James Dalton.

Real life is again presented in the person of the magistrate, Sir John Gonson, terror of thieves and whores, who breaks in with his posse. The likeness of the zealous official was so well caught that when the print was first published a member of the House of Lords, it is said, showed it to some of his fellow peers and caused a general rush to buy copies.

The fame of the series was said to date from that moment. The engraved portraits of Doctor Sacheverell and Macheath, hung side by side in the Drury Lane lodging, are those of disturbers of the peace, the author of fiery sermons in the High Church and Tory interest no doubt being considered fit company for the knight of the road.

The fourth scene brings Moll Hackabout to Bridewell, house of correction for vagabonds and 'night walkers' among whom she is by this time numbered. Here is the long shed in which the prisoners, male and female, beat hemp, the strong cord that among other uses provided the hangman's rope; the overseer with the whip as freely applied to women as to men, the stocks, punishment for the idler, the sad mingling of young and old, the innocent, the depraved, the disease-ridden. In these surroundings,

Moll Hackabout seems scarcely to know what to do with the hammer she holds, as she stands, dressed in a fashionable style that looks out of place, the pathetic finery evidently in which she had walked the streets and wore when she was arrested. Such an incongruity was possible in fact. Hogarth may have taken note of a report in the *Grub Street Journal* in 1730 that a Drury Lane prostitute, Mary Moffat, imprisoned in the Tothill Fields Bridewell, there beat hemp 'in a gown richly laced with silver'.

By what stages she arrived at the miserable end pictured in the fifth scene of the series is left to the spectator to imagine – such conditions as the *New Newgate Calendar* describes, 'exposed to the rude insults of the inebriated and the vulgar, the impositions of brutal officers and watchmen and to the chilling blasts of the night during the most inclement weather in thin apparel, partly in compliance with the fashion of the day ... ' The last two scenes are the grimmest in the activity surrounding the stillness of death. The ugly familiar who had become attached to the girl expostulates with the quack doctors wrangling over the effectiveness or otherwise of their respective nostrums – again taken from real life and understood to represent the 'doctors' John Misaubin and Joshua Ward. In the time that has elapsed since her release from Bridewell, Moll Hackabout has had a son, a child unaware of her end and intent on toasting a piece of meat by the fire.

That nothing should be wanting to complete the story even at the risk of anti-climax there is finally the gathering of prostitutes at the undertaker's, round the coffin (labelled clearly 'M. Hackabout, died Sept. 3rd, 1731, aged 23') Drury Lane has clubbed together to provide, it can be assumed, as well as the flagons of spirits that have induced the appearance of grief. Black comedy reaches its height in the tipsy pseudo-clerical mourner, watched disapprovingly by the old familiar in whom a spark of feeling remains; the woman who picks the undertaker's pocket while he helps her on with a glove; the hag who howls as custom and a liberal measure of French brandy prescribe; the child grotesquely swathed in adult black, who winds his top as indifferent to his surroundings as when previously he had busied himself with his supper.

The repercussions of *A Harlot's Progress* were many. For the artist it was an argument against confining himself to paintings for the individual buyer. The years went by before Alderman Beck-

ford, in 1745, paid 84 guineas for the series in the original painted form. Their quality is only to be guessed at from the engravings, as they were eventually destroyed by fire at Fonthill. The engravings, an immediate success, promptly gaining 1200 subscribers, made clear the advantage of circumventing the patron by addressing the general public. They went into a multitude of homes. With what grave interest, it may be imagined, a family such as the Strodes would ponder the tale of vice and woe and append their own respectable moral.

Success had its annoyances. The predatory horde that supplied the publishers with burlesque pieces and illustrations borrowed from any profitable source were quick to make their faked copies and lurid parodies of the series in text and picture, including adaptations for the stage. An artist had no defence against the pirating of his prints, as Hogarth realized all too well. Never one to suffer meekly or in silence, he launched the petition resulting in the Copyright Act of 1735 that checked, if it did not entirely stop, the flood of imitations.

Success was a strong inducement to carry his social survey farther on similar lines in the immediate sequel, *A Rake's Progress* and (after an interval) *Marriage à la Mode*. The themes of a young man who comes into money and gets through it and of a marriage of convenience, might have their examples at any time or anywhere, but though far from being peculiar to Hogarth's world they enabled him to survey its every stratum.

A Rake's Progress was more varied in significant detail and change of scene than the earlier series. It begins amid the hoarded treasures of the father who has just died. Many items accuse the old Rakewell of being a miser. Guineas tumble down from secret hiding places behind the wall to which funeral crêpe is being tacked. Meanwhile the young Tom Rakewell has celebrated his inheritance by ordering new clothes for which he is being measured. He tries at the same time to placate with a handful of gold the mother of the girl he has seduced. After this melodramatic opening the eighteenth century sets before him its varied lures. The Rake's levee assembles a wonderful array of characters eager to serve a foolish young man with money to burn.

They are professors of many arts, some of them known celebrities of the time. There is Dubois, the fencing master, making a pass with his rapier; Essex, the dancing master, daintily on his

toes; Figg, the prize-fighter (looking with some contempt at the others), ready to instruct in the use of the quarter-staff; Bridgeman, the landscape gardener with a tempting garden plan; while a stout and sinister-looking Captain evidently proposes himself as personal henchman.

Rakewell keeps a stable and his jockey brings him a silver cup, lately won at Epsom. A hunting acquaintance blows a sporting blast on the horn. Sporting tastes appear also in the framed pictures of fighting cocks, on either side of a *Judgment of Paris* that suggests another kind of connoisseurship. The musician at the piano studying the score of a new opera *The Rape of the Sabines* may or may not have been Handel, but attests a patronage of music that the long scroll on the back of his chair affirms. The list of gifts to the Bolognese singer Farinelli (Carlo Broschi), who made his successful appearance in London in 1734, conveys the homage of the nobility and gentry. Its length and the nature of its items indicate their extravagant worship of such foreign performers – and also one of the many ways in which it was possible to waste money. Among such entries as a pair of diamond knee-buckles, a diamond ring, a bank note in a gold case, is a gold snuff-box chased with classical imagery, 'Orpheus charming the Beasts', the gift, one can read, of 'T. Rakewell'. After the tempting programme for living in the world of fashion thus set out, comes no less plausibly the descent into London's night life. One of Hogarth's most vivid conceptions is the riotous scene in the Rose Tavern in Drury Lane, in which the Rake has landed after an evening's dissipation. Round Covent Garden and in Russell Street was a whole cluster of coffee-houses and taverns of varying degrees of respectability of which the Rose was one. Some were the resort of men of letters and politicians who played piquet and enjoyed intellectual conversations until midnight, such as Tom's, Will's and Button's. Dryden had presided over critical debate at Will's Coffee-house, where he had his own special chair. In the same street as these superior establishments, the Rose Tavern was distinct as a place where 'painted beauties' congregated. Its long and notorious history, often referred to by writers, continued until 1766, when it made way for Garrick's enlargements to the Drury Lane theatre.

In this authentic setting the Rake lolls, stupidly merry, while around him animation reaches its height. The many details,

though they can be separately examined, are all essential to the total effect of movement and even of noise, so closely linked in suggestion is sight with sound. Noise drowns the doleful melody of the ballad singer who stands by the door unheeded. Two 'painted beauties' quarrel and one spits at the other – an incident seen in actuality that had stayed in the artist's mind. A 'posture-woman', the strip-tease artist of the time, goes into her act. The wantonly destructive mood of the drunken assembly has broken a mirror, defaced the portraits of the Caesars on the wall, except (a nice touch on Hogarth's part) that of Nero, while one of the girls, symbolically enough, sets fire to a map of the world. The watchman's lantern and stave on the floor are the Rake's spoils from a brush with the law earlier in the night. By now he has drunk enough to be unaware of the adroitness with which one female takes his watch and hands it to another behind his back.

Daytime London is vivid in the following scene when the Rake is confronted by the sheriff's officers with a warrant for his arrest for debt. Hauntingly familiar, with the historic landmark of St James's Palace at the end, is the perspective of St James's Street where they have halted his sedan chair. The paintings that preceded the engravings give the better version, the addition of thunder and lightning in the print tending to divert attention from the Rake's predicament. Dressed in the last word of masculine fashion, he is bound for the birthday levee of Queen Caroline. His powdered wig, meticulously tied cravat, light blue coat with elaborate gold facings and gold-headed cane (this last on the point of being abstracted by a ragged shoeblack) denote the importance of the occasion, precisely dated by the leeks in the officers' hats. March 1st, the day of the levee, is also St David's Day, when the Welshmen sport the national emblem. The Rake is presumably saved from arrest by the intervention of Sarah Young, who made her mournful appearance in the first scene, returning good for evil by the offer of her small savings as a milliner. A recurrent figure in the story, she is again disappointed when her treacherous lover, in the next episode, is married to a rich old woman. With his always keen sense of the fitting locale, Hogarth places the ceremony in the old church of St John the Evangelist at what was still the village of Marylebone, a forlorn edifice approached by lanes through fields. The church had decayed with the decay of

the village, soon to become part of the town. There were few signs of its having been 'beautified' in 1725 as an inscribed panel in the gallery claimed. Its disrepair caused it to be pulled down in 1741.

In the chilly, cramped interior with its peeling walls, its usual emptiness stressed by a spider's web over the poor-box, the wedding of the ill-assorted couple has a surreptitious as well as a cold aspect. The lady's maid, a little boy from the local charity school, placing the hassock for the bride to kneel on, two dogs with their canine parody of courtship, serve only to throw emptiness into relief. Yet somehow Sarah has got wind of the secretive affair. With his child in her arms, she and her mother vainly try to halt the proceedings.

The marriage has gone forward, the Rake has since begun to make use of his wife's money and to lose it on the tables at White's Chocolate House in St James's Street, haunt of the compulsive gambler. Hogarth, topical as ever, refers to the fire that broke out in the premises in 1733. The company, intent over winnings and losses, is oblivious to the clouds of smoke pouring into the room. Transcending the varied expressions of calculation, greed or gloom is the intense despair of the Rake who has lost, shocked out of his habitual vacancy of look into impotent fury.

Fury gives way to the hopeless misery of the Fleet prison to which he is next conveyed. The old wife screams reproach, his penniless state is made plain by the turnkey who harries him for payment of his dues, the potboy who stands sullenly with the beer he is unable to pay for. From his own early memory of the Fleet Hogarth knew what grandiose and futile schemes poor debtors conceived. The would-be alchemist crouches in a corner over his furnace. A crazed and bearded figure has devised 'a new Scheme for paying ye Debts of ye Nation'. The Rake himself has written a play and sent it to the theatre manager, John Rich. Its return with the laconic message 'Sir, I have read your Play and find it will not doe' is the last straw. Sarah Young, still dogging his steps, faints at the sight of one so changed from the young man fresh from Oxford she had first known.

Reduced to imbecility, Tom Rakewell is consigned at last to the lunatic asylum 'Bedlam', as the Hospital of the Star of Bethlehem had come to be known. Founded in the reign of Henry III and for centuries devoted to the care or incarceration of the mentally

deranged, it had been rebuilt in Moorfields in 1675. The dismal-looking structure amid squalid houses, shops and market stalls was made the more forbidding by the figures of Melancholy and Raving Madness that crowned the entrance gate, designed by the Danish-born sculptor Caius Gabriel Cibber, father of the poet Colley Cibber. Oliver Cromwell's gigantic porter who became insane is said to have been his model for these nude effigies, poetically referred to as 'Great Cibber's brazen, brainless brothers'. There was a distant memory in their pose of Michelangelo's *Night* and *Day*. Hogarth adapted this reclining posture to his vision of the Rake *in extremis*, with bewildered hand to his shorn head, half-naked but still to be chained with leg irons after an attempt at suicide and still bemoaned by the loyal Sarah.

A long row of cells housed the inmates, those considered harmless being allowed to move around the corridor outside and pursue their obsessions with some measure of freedom. It is a comment on a lack of feeling in the age or a lack of understanding of the aberrations of the mind, that the world of fashion could stroll through these corridors as if at some humorous entertainment. There is an eerie contrast between the visiting ladies of fashion and the pathetic beings they have come to see. The trivial tale of folly and extravagance turns at last into tragedy that brought Timon of Athens to Charles Lamb's mind and foreshadowed the macabre conceptions of Goya.

The spectacle of decline and fall was again to be Hogarth's subject ten years later and on a more grandiose scale in the superb panorama of contemporary life, the *Marriage à la Mode*. As before the plot was simple in outline, the story that of a marriage of convenience between the son of a bankrupt nobleman and the daughter of a wealthy tradesman. Neither the young man nor the young woman, it is to be assumed, has any regard for the other but rather an underlying dislike for which the mercenary arrangement might be blamed, persisting in scenes of self-indulgence on both sides and leading to a fatal outcome. On this theatrical framework, it was possible to construct a picture of society at every level, even richer in circumstantial detail than *A Rake's Progress*. Hogarth, so well provided with images of the Fleet, Bridewell and Newgate, was able to direct as keen an eye to the modes and manners of the growing West End, none the less vividly because of his aversion from the species of culture it represented.

The opening scene is made easy to 'read' by its many clues. The Earl of Squanderfield, old and gouty, points to the record of ancient ancestry in the pictured family tree as a bargaining counter in the transaction that brings him banknotes and gold. Through the window one sees the product of his own reckless expenditure, a pretentious building left unfinished through want of funds. The alderman, shrewd in the ways of commerce, gives careful scrutiny to the marriage contract. The nobleman's son lounges by a mirror in narcissistic complacence. The alderman's daughter sits sulkily apart, listening to the compliments of the lawyer, 'Silvertongue'.

There follows the famous scene of weariness and disillusion, shortly after marriage. The action explains itself. The interior setting, beautifully painted, seems likely to have been derived from one of the mansions in Arlington Street, built towards the end of the seventeenth century and approved in George II's time as combining the advantages of town and country. Statesmen and members of the nobility lived there and Hogarth may have drawn on his memory of No. 5, the town house of Sir Robert Walpole, where he died in 1745. Indicative of the taste of the time in decoration, here quietly mocked, is the rococo fantasy of the wall clock and the chinoiserie over the mantel on either side of a renovated antique bust.

That the estrangement between the young Earl of Squanderfield (who by now has inherited the title) and his Countess is practically complete, is the burden of the two following scenes, the 'Visit to the Quack Doctor' and 'The Countess's Morning Levee'. The Earl taking his own dissipated way has, it can only be concluded, acquired from or transmitted to the young girl with him some form of venereal disease that the quack doctor has professed to cure. He is the Doctor Misaubin who made an earlier appearance in *A Harlot's Progress*, also known as Monsieur Pillule who receives them in his house in St Martin's Lane, amid a miscellany of the objects respected by the superstitious and credulous as possessing some magical value.

The interest in exotic and natural curiosities so worthily represented at the time in the collections of Sir Hans Sloane, is debased by Dr Misaubin into the semblance of a sorcerer's cavern. The alligator, the narwhal's horn, the anatomical figures, the absurd machinery for drawing corks and setting dislocated shoulders, give a spurious suggestion of profound research and science.

What is going on is perhaps purposely left vague. We must make what we can of the charlatan's grin, the matronly woman present who makes an angry gesture with a knife, another 'Mother Needham' to the sobbing girl it may be; the box of pills the Earl holds out with an expression of callous gaiety seeming to make light of the whole situation; what is not obscure is the atmosphere of sordid transaction.

Meanwhile the Countess has her own diversions in the morning gathering in her boudoir while a French hairdresser puts her hair in curling-papers. Music is provided by foreign musicians of the kind Hogarth heartily disliked. One of the Italian *castrati* for whom there is a vogue warbles his song, accompanied by a German flautist. A woman visitor, the wife of a sporting man who has unfeelingly gone to sleep, leans forward in affected adoration. It must be the Earl himself with his hair in curlers who directs a sour morning look towards the Countess as she discusses the costume for the night's masked ball with the ever-attentive Silvertongue, indolently and even insolently at ease on the couch beside her.

Details are as always significant. The collection of trumpery ornaments she has bought at an auction includes the horned statuette of Actaeon, which in the circumstances takes on an extra meaning. A copy of Correggio's *Jupiter and Io* adds its voluptuousness to the framed pictures among which the portrait of Silvertongue figures. She has been reading the latest French novel, or so-called *conte morale*, just out, *Le Sopha* by Crébillon *fils*. This frivolous fairy tale about an Oriental courtier who incurred the punishment of being turned into a sofa and, as such, told what he saw and heard, gains suggestiveness from lying on the couch where the amorous lawyer reclines.

The last two scenes, of murder and suicide, bring the tensions of the series to their climax. In the 'Killing of the Earl' there is an instantaneous impression of things happening in a moment of time. The Earl has surprised the Countess and her lover in the house of assignation they have gone to after the masked ball. Held in suspense are the few minutes in which the Earl, mortally wounded by Silvertongue's panic thrust, staggers, his falling sword hanging for a second in space: his murderer escapes through the window in his shirt, the Countess wrings her hands in horror, the landlord and the watch burst in through the door. Light touches

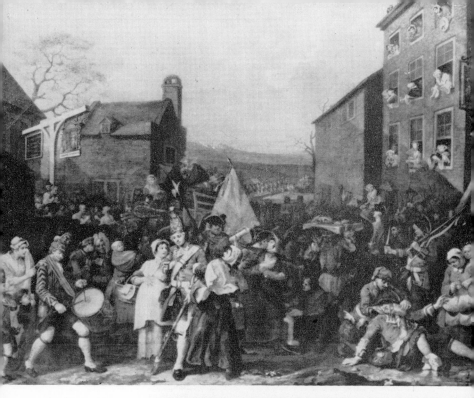

16 *The March to Finchley (March of the Guards towards Scotland in the year 1745), 1746*

17 Hubert Gravelot, *Le Lecteur, c.* 1746

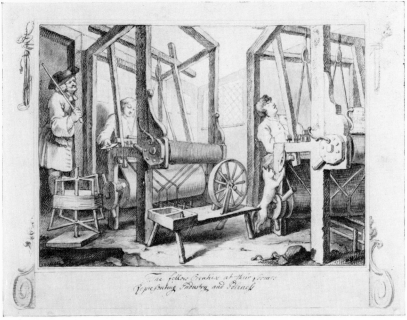

18 Top: *Moses Brought to Pharaoh's Daughter,* 1746
19 Bottom: *The Fellow Prentices at their Loomes. Representing Industry and Idleness,* 1747

the figures and the discarded fancy dress on the floor with un-
relenting sharpness. Hogarth with his unfailing sense of setting
makes the room sombre and bleak in spite of attempts at decora-
tion. How crude they are appears in the fanciful portrait of Moll
Flanders or her like so carelessly flung over the dusky wall paint-
ing of the Judgment of Solomon that the legs of one of Solomon's
bodyguard appear to be its grotesque extension.

The death scene of the Countess who takes poison after learning
that her lover has been tried for murder and hanged, is in her
father's house to which she had returned. The alderman lives in
an old-fashioned residence in the City near the Thames. The case-
ment opens on the old London Bridge, surviving (until 1757) in
all its tottering antiquity. His taste in pictures is for the Dutch and
Flemish schools though in examples of no better quality, Hogarth
seems to convey, than old Squanderfield's 'dismal dark pictures'
of St Sebastian and St Lawrence on the Gridiron. A frugal way
of life has its evidence in the simple fare set out for a midday meal,
the pig's head, gnawed by a skeletal dog while attention is directed
elsewhere.

There is nothing more left to do for the doctor who is seen
departing. The apothecary scolds the idiot servant who has
brought the fatal bottle of laudanum, now lying empty on the
floor. The old nurse holds up the frail, rickety child to its dead
mother in vain. With his business-like prudence and no sign of
emotion her father takes the ring from her finger for safe keeping.
On no stage play could the final curtain be drawn with more effect.

~~ 13 ~~

The Artist and the Writers

It has always been tempting to put into words the stories told by Hogarth in pictures. His inventiveness in detail has called for its verbal relish and translation. The constant movement of his transient scenes has invited enlargement at any given point of the action on what had gone before and what might come after. In total assessment of the great artist's genius other qualities may be sought besides the link with literature so effectively remarked on by Charles Lamb. 'I was pleased with the reply of a gentleman who being asked which book he most esteemed in his library answered "Shakespeare", being asked which he esteemed next best, replied "Hogarth". His graphic representations are indeed books; they have the teeming, fruitful suggestive meaning of words. Other pictures we look at, his prints we read.' There is nothing to show that Lamb had any thought of the painted originals. A different focus of vision was needed to savour the lusciousness of brushwork, the colour harmonies of lemon, pink and grey in such a painting as that of the 'Countess's Levee'. There can be no doubt of Hogarth's great influence on the world of letters. Writers of every degree of ability took note of the way he told a dramatic story. The immediate success of his 'modern moral subjects' inevitably produced many imitations, though the important result was the creative impetus they gave to the shaping of the Georgian novel.

At the lowest level were the unscrupulous pilferings of 'Grub Street', the sub-world of art and letters. The name that long outlasted the eighteenth century was then already in use as a description of the struggling existence of the hack. Dr Johnson defined it in his Dictionary as 'a street in London much inhabited by

writers of small histories, dictionaries and temporary poems; whence any mean production is called Grub Street'.

Some to whom the description might apply were as harmless as Hogarth's father had been. Not unsympathetically the artist in 1735 portrayed the *Distressed Poet* in his miserable attic, distracted from his verses by the entry of a milkmaid demanding payment of her bill. But others were a rapacious tribe, whose efforts to profit by the fame of Hogarth's prints throw a lurid light on the lawlessness then prevalent in publishing. They included the pirates who made inferior copies of his engravings, sold in the print shops at half the price of the genuine originals. Scribblers were called in to supplement them with explanatory pamphlets, *A Harlot's Progress* in particular giving occasion for much pretended moralizing that was no more than a cover for lewd suggestion.

Titles and episodes were borrowed with impunity. A 'ballad-opera' in 1733 *The Jew Decoy'd; or the Progress of a Harlot* was a garbled version of the second episode of the series. A master of literary fraud, the bookseller and pamphleteer, Edmund Curll contrived a composite imposture, in the cover of a poem published in book form in 1733, *Mr Gay's Harlot's Progress*. The confusion of the supposed author, Joseph Gay, with John Gay of *The Beggar's Opera*, intentionally misleading, was further confounded by changes in the title-page and the sly promise of 'The Lure of Venus', as a description of Hogarth's work. At this time Curll was searching around for memoirs of the real Gay, who had recently died; which led the satirical Arbuthnot to describe the man of many frauds in a letter to Swift as 'one of the new terrors of death'.

An unblushing misrepresentation was a pantomime devised by Theophilus Cibber, the actor son of Colley Cibber, entitled *The Harlot's Progress* and dedicated to 'the Ingenious Mr Hogarth' in spite of making nonsense of his work. The piracy and distortion of both prints and ideas were ample reason for the petition of Hogarth and others that secured for writers and artists a measure of legal protection. But apart from the flood of imitation the 'modern moral subject' elicited from the denizens of Grub Street, it made a deep impression on the most gifted of Hogarth's contemporaries. Swift admired him as a kindred spirit, though attributing to him too much of his own misanthropy:

Were but you and I acquainted,
Every monster should be painted
You should try your graving tools
On this odious group of fools;
Draw the beasts as I describe them
Form their features, while I gibe them
Draw them like, for I assure ye,
You will need no *car'catura* ...

Hogarth can hardly be credited with any such hatred of human beings in general as the verses from Swift's *Legion Club* imply, nor in his case did to 'draw them like' amount to caricature.

What was *caricatura*? It worried Hogarth that the word was so often applied to his works. The illiterate, it seemed, could make no distinction, obvious though it seemed to him, between character and caricature. He tried to make the distinction clear. 'I have ever considered the knowledge of character, either high or low, to be the most sublime part of the art of painting or sculpture; and caricature as the lowest, indeed as much so as the wild attempts of children when they first try to draw.' The distinction was not always so easy to make as might be thought. Comedy in the realistic description of life had its attendant spirits and rivals in the shape of farce, parody, burlesque, travesty, ready to slip into its place. Now and then he approached caricature as in his *Taste à la Mode* (1742) in which exaggeration of clothes and expression went amusingly beyond realism into the realm of the grotesque.

The stage, which influenced him so much, had its own distinction to make. Actors represented human beings with just so much emphasis on expression and gesture as was indeed to make clear the action going forward. The looks of frivolity, folly, bewilderment or distress in the prostitute, the rake or the couple whose marriage has gone wrong, as he depicted them were those of normal humanity. The hapless creatures of fate could well be spared the brutality of laughter on the part of their portrayer. The clearest distinction could be drawn between the possible and the impossible, trenchantly made by Henry Fielding in the Preface to *The History of Joseph Andrews*. The aim of caricature, he said, 'is to exhibit monsters, not men; and all distortions and exaggerations whatever are within its proper province'.

This and other remarks in the Preface that set out the nature

and aims of the 'comic-epic poem in prose' show not only an agreement with Hogarth's attitude but how much he had been impressed by Hogarth's example in the rendering of character. 'He who should call the ingenious Hogarth a burlesque painter, would, in my opinion, do him very little honour; for sure it is much easier, much less the subject of admiration to paint a man with a nose, or any other feature, of preposterous size or to expose him in some absurd or monstrous attitude, than to express the affections of men on canvas.'

The comic and burlesque strictly defined were as far apart in writing as in Hogarth's painting. When Fielding came to write his novels Hogarth was to prove an endless source of inspiration. It had taken some time for Fielding to reach a similar standpoint to that of the painter. His criticism of the burlesque implies a criticism of his own early productions. The son of General Edmund Fielding and the grandson of the Earl of Desmond, he had been to Eton and afterwards for a while to Leyden University, but financial support was less readily forthcoming after his father's second marriage. By 1728 he was an impecunious young man in London, leading a careless, Grub Street sort of life and embarking on a series of stage plays and farces for a living.

Mockery, so much in the mode, suited his satiric humour, nourished by Cervantes and Molière. His burlesque of James Thomson and others in *The Life and Death of Tom Thumb*, 1731, of contemporary play-writing in *Pasquin*, 1736, were popular parodies. A frontispiece to *Tom Thumb*, a subscription ticket for *Pasquin* designed by Hogarth were marks of his friendly acquaintance with the author. The sensation caused by *A Harlot's Progress* is reflected in the parody of pompous drama, *The Drury Lane Tragedy*. The last of Fielding's stage plays, *The Historical Register for 1736*, satirizing Walpole, was a political burlesque that incurred the veto of the Lord Chamberlain exercised according to the Licensing Act of 1737.

The change of course that followed, taking him away from the stage and leading him to novel writing, revealed the true nature of his abilities. He began his first novel, *Joseph Andrews*, with the aim of parodying Samuel Richardson's great success, *Pamela or Virtue Rewarded*, the talk of the town in 1740. The character of its author and of the work itself were alike alien to Fielding. The sophisticated dabbler in stage skits with an acutely developed

sense of the ridiculous, had nothing in common with Richardson, the solemn moralist and very model of an industrious apprentice. Always diligent and earnest, after his start as a printer's apprentice in the City, Richardson became a compositor and proof-reader, married, printed newspapers, was appointed Printer of the Journals of the House of Commons, then Master of the Stationers' Company and King's Law Printer.

He was fifty before the idea of a novel took shape from the proposal put to him of producing a guide to letter-writing for those who did not know what to say or how to say it. The help in this respect he had given to several young women had made him apt to put appropriate words into their mouths. The sample letters he prepared suggested a story in epistolary form. Thus *Pamela* was born — 'a series of letters from a beautiful young damsel to her parents, published in order to cultivate the principles of virtue and religion in the youth of both sexes'. Rapturously received by a general public, the work so conceived was repellent to Fielding's critical humour. There was something that jarred in the prim form of words that defined the aim. And then, were the principles of conduct set forth as virtuous and moral as they professed to be? The cynic might redefine the morality of the story as the best way to catch a husband.

Fielding began to write a parody but as the tale advanced, something unexpected happened, the characters came to life. Instead of caricatures they turned into people as convincingly real as those Hogarth had painted and drawn. So far were they on the same track that the memory of types and expressions in the engravings was constantly before Fielding as he wrote and when he wished to convey a visual image it was Hogarth he referred to for a likeness.

The surprise of Lady Booby in *Joseph Andrews* when Joseph rejects her advances brought to mind 'the inimitable pencil of my friend Hogarth'. His scenes and characters were once again the subject of admiring acknowledgment in Fielding's greatest novel, *Tom Jones*, that followed in 1742. The pedagogue, Mr Thwackum, 'very nearly resembles that gentleman who in *The Harlot's Progress* is seen correcting the ladies in Bridewell'. Fielding sighs for the pen of Shakespeare, the pencil of Hogarth, to describe the terrified messenger who brings news of Sophia's disappearance to Squire Western. His own description of the serving-man with 'chattering

teeth, faltering tongue', fits perfectly the servant taken to task in the last scene of *Marriage à la Mode*. Mrs Bridget Allworthy was copied from the elderly lady walking to Covent Garden church 'with starved footboy behind her carrying her prayer-book' in the first scene ('Morning') of Hogarth's *The Four Times of Day*.

Often though Hogarth descended into the social depths in the footsteps of his erring characters, he did not specifically portray, though he might well have done so, the 'prince of thieves', Jonathan Wild; but the spectacle of the desperate underworld in which this character of real life had his eminently criminal and perfidious part was an Avernus in which Fielding had Hogarth for guide. Fielding's *History of the Life of the late Mr Jonathan Wild the Great* pursued this 'hero' through many a Hogarthian scene to the 'consummation of Greatness' – the scaffold. He sketched the procession to Tyburn with a vividness matching that of Hogarth in depicting the fate of the Idle Apprentice. The mock-heroic reached its height as the 'Ordinary' (i.e. the Chaplain of Newgate) 'being now descended from the cart, Wild had just opportunity to cast his eyes among the crowd and to give them a hearty curse, when immediately the horses moved on and with universal applause our hero swung out of this world'.

Without Fielding's mordant capacity, and coarser in humour than either he or Hogarth, Tobias Smollett is linked with them in the delight in character and profusion of incident of his novels. Experience gained by his early employment on board ship as 'surgeon's mate' enabled him to give a unique account of life in the British navy, including the eye-witness description of the attack on Cartagena in *Roderick Random*. Later he saw much of the world in travel abroad, though showing as strong an insular prejudice as Hogarth himself in his comments on Continental ways. He had an equal appreciation of life at various social levels and in degrees of roguery, though he did not make as clear a distinction between character and caricature as that on which Fielding and Hogarth concurred. Without his occasional references to the 'inimitable' Hogarth, it would still be possible to trace his influence in Smollett's character-drawing. The 'tall, long-legged meagre, swarthy' figure of the cook at Boulogne in *Peregrine Pickle* recalls the starveling figures of Hogarth's *Calais Gate*. The novelist and the painter were often close in exuberance, apart from such a specific instance, where it might be said the novel illustrated the

picture. The work of Smollett has its kinship with the last great series of subject pictures that Hogarth painted, *An Election* of 1755. Here was the England that Voltaire described as going mad every seven years, letting itself rip in a riot of physical action. The drunken revelry of the election entertainment, the bribery and corruption of the rival canvassers for votes, the haling of the incapable to the poll and finally the chairing of the member, borne aloft in precarious triumph, occasion for a vigorous exchange of blows between the rival partisans of 'Guzzledom', was Georgian popular life as Smollett might have described it, formidable in its energy and portrayed without a political attitude or attempt to extract a moral lesson in the purest spirit of comedy.

14

The Artist and
the World of Theatre

While Hogarth furnished so much material for the novelist without conscious intention, his interest in the world of the theatre remained constant. To him a laughing audience was as good as a play and so appears in lively expression in the engraved subscription ticket in 1733 for *Southwark Fair* and *A Rake's Progress*. Theatrical make-believe had its humorous attraction for the realist, even in its most rough-and-ready form. There is no more delightful print among Hogarth's works than the *Strolling Actresses Dressing in a Barn*. The farce *The Devil to Pay in Heaven* is to be presented 'By a company of Comedians' (so the playbill reads) 'from the London Theatre at the George Inn', this being 'the last time of acting before the Act commences'. The Act was the Licensing Act of 1737 intended to confine dramatic performances to the Drury Lane and Covent Garden theatres and putting an end to the improvised stage of the inn yard as well as to a satirical venture such as Fielding's Haymarket Theatre. The contrast between the ruinous barn and the pomp of stage properties piled up in confusion, the clothes lines with their poor scraps of washing and the regalia of 'Juno', who is having a hole in her stocking mended, the incongruities of dress and undress, in 'Diana', practising histrionic attitudes while still in her shift, in the two small devils in impish costume swigging from tankards of porter – all this is combined with a hundred details, crowns, shields, fasces, helmets, and pieces of stage machinery bearing on the action. In a remarkable way, the composition, for all its slipshod detail and play upon squalor, resolved into a kind of magnificence.

Hogarth's manifest affection for the stage entailed a personal

acquaintance and friendship with its performers and promoters. Though he had no contact with Gay, save through the medium of his opera, he came to know Fielding when the latter was still occupied with his stage farces and satires. Later he was the friend of Garrick in the earlier years of the great actor's career. Even before they met, Hogarth displayed the interest in Shakespeare that was to be one of the links connecting him with Garrick. It was an interest he shared with his painter friend Francis Hayman, who was also a man of the theatre to the extent of having been a scene-painter. It was said of him by the then Lord Radnor that 'if he had not fooled away many years at the beginning of life in painting Harlequins, trap-doors etc. for the playhouse, he would certainly by this time be the greatest man of his age ...' It would seem too sweeping to say either that his theatrical experience was wasted or that he had the capacity of greatness, but in various ways he contributed as Hogarth did to the visual interpretation of Shakespeare that was to play so conspicuous a part in the later development of eighteenth-century art in England.

The Shakespearian drama, roughly treated as it had been, revised, garbled, virtually rewritten at various times, had survived to the admiration of the Augustan and early Georgian periods, despite the vulgar competition of pantomime and parody, and the vogue for Italian opera. The versions of Colley Cibber, actor, theatre manager, writer of comedies as well as Poet Laureate, who said of one play, 'I have endeavoured to make it more like a play than I found it in Shakespeare', long held the stage. They weathered Pope's scorn in *The Dunciad* for 'the old revived new piece'. Cibber could interpolate a line of his own as celebrated as 'Off with his head! So much for Buckingham' in his production of *Richard III*.

At about the same time as Hogarth painted the scene from *The Beggar's Opera* he made sketches of Cibber's version of *Henry IV Part 2*. His painting of Falstaff examining recruits, with suitable emphasis on Falstaff's massive proportions, followed in 1730. He joined with Hayman in suggesting and making apparently some contribution to the decorative paintings for Jonathan Tyers's venture in open-air entertainment at Vauxhall.

Tyers, whose shrewd and business-like air is preserved in a portrait bust by Roubiliac, opened Vauxhall Gardens in 1732 as an enlarged and altered version of the old tea gardens where

Londoners had foregathered. Visitors who came by water landed at the entrance on the river front. They could wander in the winding walks and groves where the nightingale might be heard and lamps among the trees made a romantic mingling of light and shade; take supper in the boxes provided and listen to the performance of the orchestra stationed in an ornate pavilion. The promoter saw the advantage of enlisting the arts of painting and sculpture as part of the gardens' theatrical effects. The Academy in St Martin's Lane offered its variety of talent. Tyers gave Roubiliac his first important commission, very welcome to one who previously had a hard struggle and was no stranger, as a poet observed, to 'the shivering hand of meagre care'. This was the life-size statue of Handel that made a handsome centrepiece in the grounds. A realistic portrait, perhaps the first to honour a living artist in statuary, it was at the same time a skilled exercise in the flowing rococo style with an added touch of allegory in the lyre Handel fingers – not an instrument on which he was known to play but assigning him the musical authority of an Apollo.

Some fifty paintings commissioned to decorate the supper boxes, representing various sports, pastimes and stage performances including scenes from Shakespeare, were mainly the work of Hayman. He made use of decorations on a small scale designed by Hubert Gravelot as well as adopting suggestions from Hogarth. Originals that have surprisingly survived to the present time, such as *The Wapping Landlady*, *The Game of See-Saw* and *The Milkmaids' Garland*, show an interesting fusion between Hayman's insular realism and Gravelot's more delicate style of rococo decoration. The Shakespearian scenes by Hogarth that supplied hints and material to be copied at Vauxhall reflect little of his genius. Its quality is absent from his engraving of Henry VIII and Anne Boleyn, presumably suggested by Cibber's production of *Henry VIII*, of which a copy was made for the gardens. Quick to seize on or invent innuendo, comment at the time professed to find a reference to Walpole in the mortified look of Wolsey in the print and to Frederick, Prince of Wales and his mistress, Anne Vane, in the leading characters. The painting eventually disappeared from public view. It would be hard to detect Hogarth's hand in the Vauxhall painting of *Fairies dancing on the Green by Moonlight* taken from Purcell's adaptations of *A Midsummer Night's Dream*. Ready as he was at all times to tackle a variety of subjects, fairies

would least be expected from him. Quite apart from Vauxhall – and another matter altogether – was his appreciation of the character and performance of actors on the Shakespearian stage.

It was a changing period in dramatic style of which his portrayal of James Quin and David Garrick gives an indication. From the portrait of Quin one gains an idea of his appearance on the stage in his embroidered velvet coat, his full-bottomed periwig; the haughty air with which he rolled out his lines in the declamatory style of the old school of acting. In contrast was little David Garrick, a new theatrical portent in his abounding vitality, his mercurial changes of expression and gesture.

Quin, as well as being a great success in the roles of Falstaff, Henry VIII and Coriolanus, was a character such as might have figured in one or other of Hogarth's panoramas of social life. He brings to mind Peachum's remark in *The Beggar's Opera*, 'Murder is as fashionable a crime as a man can be guilty of. How many fine gentlemen have we in Newgate every year, purely upon that article!' In fact he was tried for murder at the Old Bailey and convicted of manslaughter, as the result of an encounter in the Covent Garden Piazza with another actor whom he ran through with the sword that no well-dressed man was then without. An earlier episode, when he was discovered with another man's wife in some place of dubious resort and drew his sword on the husband who had tracked them down, was like Scene V of the *Marriage à la Mode*, except that the husband received a less than fatal wound. The many stories of his arrogance include the sad tale of the author who gave him the script of a tragedy to read. Quin pocketed the manuscript carelessly and promptly mislaid it but when asked for his opinion answered, in the words Hogarth attributed to Rich in refusing poor Tom Rakewell's play, 'It will not do'. Pressed further, he admitted having lost it but added insult to injury by saying, 'There's a drawer full there of tragedies and comedies never acted. You can take any two of them instead'.

He had a greater respect for his young rival, David Garrick, 'light in every muscle and in every feature' as he was described, the pioneer of a new and brilliant mode of acting that was the opposite of Quin's singsong delivery and portentous presence. It was a tense moment when on one occasion they came on the stage to act together. To Hogarth, for whom his pictures were a stage, the animation of Garrick in his tragic and comic roles had a special

attraction. Their personal friendship is a pleasant story. Garrick was so far 'all things to all men' that John Wilkes could say of him with paradoxical malice that he had no friends and even Dr Johnson when questioned by Boswell gave it as his opinion that Garrick had many friends but no one intimate. Yet his warm regard for Hogarth is evident in his own words, 'I love him as a man and reverence him as an Artist'. His reverence had its practical expression in his acquisition of many of Hogarth's engravings. Well calculated to appeal to the actor were the different faces of mirth in *The Laughing Audience*, the Bohemian but still professional circumstances of the *Strolling Actresses dressing in a Barn*, the cross-section of entertainment in *Southwark Fair*. It is a sign of his loyalty that he was the one person to appear for the draw when Hogarth raffled the series of Election paintings, offering 200 chances at two guineas a stake. Without wishing to take advantage of his being the solitary contestant, he threw the dice as Hogarth insisted, but later proposed the equitable solution of paying 200 guineas for the set of four pictures.

Garrick loved being painted and artists loved to paint him, in both the tragic and comic roles that displayed his versatility. Hogarth painted his memorable picture of the actor in the part of Richard III about 1745; Garrick was then twenty-eight. He had come to London from Lichfield eight years before, in company with his ex-tutor, Samuel Johnson, 'with a great hunger for money', said the latter, combining candour with affection, and describing him as 'the son of a half-pay officer, bred in a family whose study was to make four-pence do as much as others made fourpence halfpenny do'. Johnson hastened to add, 'But when he got money he was very liberal'. Having quickly tired of dabbling in the wine trade with the legacy of £1,000 from an uncle who made a fortune in the business, he turned to the theatre. In 1741 he had gained an instant success in Cibber's version of Shakespeare's *Richard III*. Especially praised was his acting in the tent scene (Act V, Scene III) when Richard starts out of the dream in which he is haunted by the ghosts of his victims. Garrick's way of gradually building up the suspense to the climax of terror that came with startling and nerve-tingling force was hard to compress into the static moment on canvas, but as much as in the horrified face, Hogarth expressed it in the spread digits of the outstretched hand warding off the nightmare visions.

As the portrait of the actor on stage the work was the forerunner of many paintings celebrating the genius of Garrick later in the century. Hayman, first introduced in his capacity of scene-painter to Garrick, also portrayed him as Richard III on the field of Bosworth in one of the several revivals of the production. He made a spirited effort to convey the singular energy of Garrick uttering the famous exclamation, 'My Kingdom for a Horse!' But Hayman was more at ease when he painted Garrick and the actress Mrs Pritchard enacting the contemporary humour of *The Suspicious Husband*, a comedy by Benjamin Hoadly, Hogarth's friend. There were many who shared Dr Johnson's preference for Garrick in his comic roles, which at the height of his fame provided Johann Zoffany and others with material for their many conversation pieces of the stage.

Garrick's mobility of feature was a challenge to those who sought to portray him in real life. After Fielding's death, when it was found that no portrait of the novelist existed, the story goes that Garrick imitated him so perfectly for Hogarth's benefit as to stir a vivid recollection of his appearance and to inspire that sardonic outline engraved for Murphy's edition of Fielding's works in 1762.

The ease with which he assumed different likenesses made Garrick an elusive subject for the portrait painter. He never looks quite the same man in the portraits by different hands that sought to show him as he was in real life – which gives point to Goldsmith's lines in his *Retaliation*:

> On stage he was natural, simple, affecting;
> 'Twas only that when he was off he was acting.

The difficulty of fixing his expression has an instance in the double portrait Hogarth painted of Garrick and his wife, the dancer Eva Maria Viegel. The composition was graceful, adapted, it is supposed, on the classic principle that there is no harm in learning from the enemy, from the painting of Colley Cibber and his daughter by the foreigner, van Loo, of whom Hogarth had so many hard things to say. Mrs Garrick, playfully snatching the quill from her husband's hand as he meditates his prologue to Samuel Foot's satire on Taste, is entirely charming. But neither artist nor sitter was satisfied with the rendering of Garrick's own features. Hogarth is said to have angrily swept his brush over the

eyes and though at some time they were painted in again it was with an uneasy effect.

Garrick outlived Hogarth by thirty years, years of mature triumph. He shared the prestige of the illustrious club, later known as the Literary Club, that came into existence at the Turk's Head Tavern in Soho on the proposal of Joshua Reynolds supported by Dr Johnson. He was as indispensably its representative of the theatre as Reynolds of painting, Burke of philosophy, Gibbon of history and Johnson of conversational wit and wisdom. Yet at no time was he forgetful of Hogarth and it was Garrick who wrote the memorial lines inscribed on the monument to Hogarth's memory.

Improving Aims

With almost too elegant a facility Garrick, expert in prologue and epilogue, dedication and epitaph, wrote of Hogarth as one 'Whose pictured morals charm the mind / And through the eye correct the heart'. In not being entirely appropriate, Garrick's verse bears out Dr Johnson's remark in making an alternative suggestion that an 'epitaph is no easy thing'. Prostitution and prodigality were not readily to be disposed of by the brush or the burin. As unlikely was the converse, that what Johnson described with a thunderous polysyllable as the 'labefactation' of principle in *The Beggar's Opera*, would turn its audiences into highwaymen and harlots. The Rev. John Trusler, in his *Hogarth Moralized*, published with the approval of the artist's widow four years after his death, carried to its extreme the tendency to look on him as a moralist above all else. The form of the title reflected the proneness of the author, who also wrote sermons for the use of other clergymen, to impose his own lessons, based on the assumption that Hogarth intended 'to improve the minds of Youth and convey Instruction under the Mask of Entertainment'.

However sanctimonious this might seem and little to be applied to the work of a painter of genius, there is no doubt that 'improvement' in a general sense was given more thought as the century progressed. A social conscience made headway against irresponsible satire. The later Henry Fielding, appointed a Justice of the Peace for Middlesex and Westminster in 1748, was a more serious person than the Fielding who light-heartedly set out to parody Samuel Richardson. The problems forced upon his attention by the nature of his office at Bow Street produced the grave reflections contained in his *Enquiry into the Increase of Robbers* and

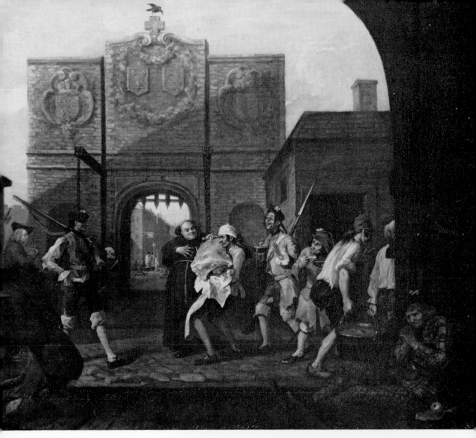

20 *Calais Gate* ('O the
Roast Beef of Old
England'), 1748

21 *The Shrimp Girl,*
c. 1745

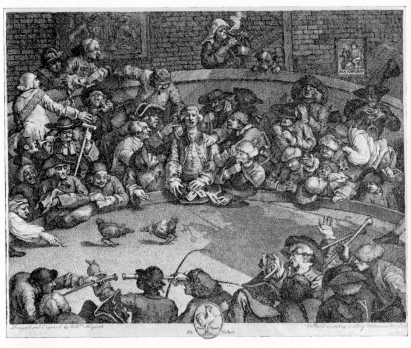

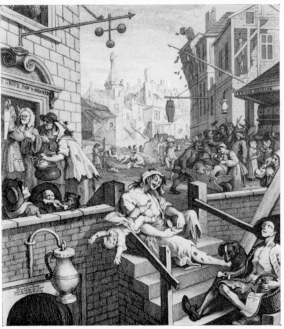

22 *The Cockpit*, 1759

23 *Gin Lane*, 1751

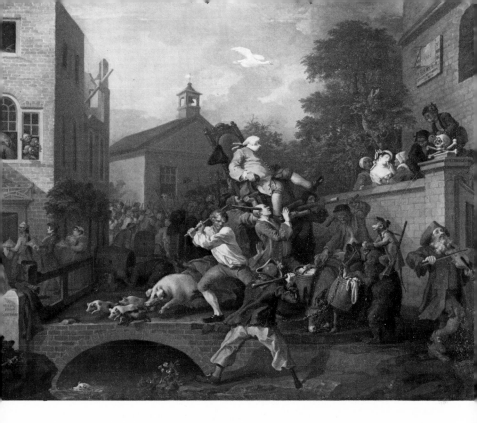

24, 25 *An Election, c.* 1754. Above: Detail of 'Chairing the Member'.
Below: Detail of 'Canvassing for Votes'

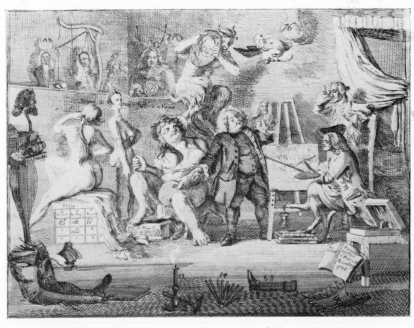

26 Paul Sandby, *Puggs Graces*, caricature of Hogarth, 1753–4

27 *Hogarth Painting the Comic Muse*, c. 1758

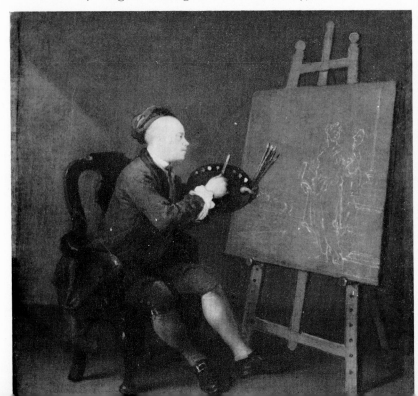

his *Proposal for the Poor*. He was troubled by such a notorious case as that of Elizabeth Canning. Opinion was hotly divided, whether as she claimed she had been assaulted and robbed or was guilty of the counter-charge of perjury. The wearisome examination of those concerned brought home the difficulties besetting a conscientious magistrate. Fielding's third novel *Amelia*, published in 1751, though it contained a lovingly remembered description of his young and beautiful first wife, reflected also some of the magistrate's judicial cares.

Virtue was still Samuel Richardson's theme in his greatest novel, *Clarissa*, published 1747–8, no less fascinating to his readers in describing Virtue in Danger than the earlier tale of Virtue Rewarded. The account at immense length of 'the Distresses that may attend the Misconduct both of Parents and Children' and the wiles of the seducer, Lovelace, was followed with breathless interest at home and abroad. Whether or not its warnings were heeded, the minute dissection of the emotions was a harbinger of the romantic age still to come. The novel found a sympathetic French translator in the Abbé Prévost, himself the author of a psychological masterpiece, *Manon Lescaut*, and had its influence on Jean-Jacques Rousseau. Highmore's portrait of the heroine delighted the novelist by its 'great intelligence, sweetness and dignity' – and positively made him angry with himself for having created her seducer – 'made me ready to curse the Lovelace I had drawn'.

Refinement was a quality attached to the wish to 'improve'. Devoted to Shakespeare as Garrick was, he did not hesitate to excise from the plays coarseness of expression or supposed indecencies with a prudishness no less than that Thomas Bowdler was later to apply to his *Family Shakespeare* and his expurgated edition of Gibbon. Refinement was an aspect of virtue in Richardson's heroines. The circle of feminine admirers to whom the novelist read instalments of his work as he completed them in his semi-rural retreat at North End, Fulham, may well have added by their comments to the nuances of feeling that were his study. A corresponding delicacy of feeling in Highmore's paintings made for their life-long friendship. They were taking tea together at North End when the novelist suffered the stroke from which he died soon after. In the painter the delicacy of style related to sentiment was formed as much by a nostalgic regard for the elegance of Van Dyck as by the French example of Gravelot. Highmore's

full-length of Clarissa was executed 'in the Vandyck taste and dress', this being a fanciful escape from realism in which he was not alone. Shakespeare was clothed in the glamorous 'Vandyck dress' of no particular period by Kent and Scheemakers in the monument of 1740 in Poets' Corner. In similar attire and reflective pose he appears again in the marble statue designed by Roubiliac in rivalry, commissioned by Garrick for the 'Temple of Shakespeare' in his garden at Twickenham. Gainsborough was to adopt the pose in his portrait of Garrick leaning against a bust of Shakespeare (destroyed by fire in 1946) and the style of dress in his *Blue Boy*.

In the mind of Hogarth there was more complexity and variation of aim than in Richardson's preoccupation with Virtue in a sexual aspect or Highmore's refinements of manner. An ideal perfection in either sex was not the affair of the realist. The suggestion that he should illustrate *Pamela* had not appealed to him. It would be still less easy to imagine him painting the hero of Richardson's last novel, the impeccable Sir Charles Grandison, in whom critics looked in vain for some redeeming flaw. 'His conscience and his wig were intact. So be it. He shall be canonized and stuffed', the French historian, Henri Taine, was to remark.

Perfect bliss was as hard for Hogarth to visualize as perfect virtue. His attempt to follow the unhappy story of the *Marriage à la Mode* series with a contrasting set of paintings of happy married life in the country remained unfinished for want of comparably dramatic situations, though they include a brilliant study of movement in the sketch of a country house dance. But once he had gained a measure of free choice as to what he should do, from the safe position ensured by the popularity of his prints, his restless moves from subject to subject reveal a continued wish for improvement in one form or another together with more disquiet than appears in some of his dogmatic statements of opinion. If he referred contemptuously to what 'puffers in books call the *great style*' he returned time and again with a characteristic obstinacy to the quest for its secret.

He was nagged by the feeling that painting in Britain needed to be raised to a higher level, even while he poured scorn on the foreign professors of lofty aims. 'History' painting in the form of the large-scale mural representing some religious subject was a challenge he could not resist taking up. The insular pride that

hostile contemporaries stigmatized as vanity, a belief that an English painter was, or ought to be, a match for any foreigner, was one of the motives, albeit as he said, 'with a smile at my own temerity', that led him to carry out at his own expense the vast canvasses for the great staircase at St Bartholomew's Hospital, the *Pool of Bethesda* and the *Good Samaritan*, with figures seven feet high.

They were also intended as an encouragement to others to venture outside the limitations of 'phizmongering', perhaps to create a 'school' that would form a natural continuance of the work of Sir James Thornhill. At the same time he was aware that the kind of religious painting that the Roman Church had encouraged in other countries had small chance of flourishing in England. The difficulties facing the painter of religious subjects were those of faith or the lack of it as well as pictorial style. Best suited to the realist were the secular episodes to be derived from biblical story. No renewed spiritual fervour inspired the versions of the *Ascension* and *Resurrection* in the altarpiece Hogarth was commissioned to paint for St Mary Redcliffe, Bristol, in 1755 (later relegated to the care of the Bristol City Art Gallery). In painting *Paul before Felix* for Lincoln's Inn in 1752 it is evident he considered how the Old Masters would have treated the subject. The style of the painting reflects his study of Raphael, accessible in the cartoons at Hampton Court, but so little was the imitation congenial that his own fluency of composition gave place to the stiffness that Joshua Reynolds pointed out in a contribution to *The Idler* in 1759. Without mention of name, it was obviously Hogarth's painting he criticized in his remark on 'an upright figure standing equally on both legs and both hands stretched forward in the same position and his drapery to all appearance without the least art of disposition'.

The place of religion in art was a question Hogarth was no better equipped than others to solve in a time when the level of belief was generally low. Critical doubt took the double form illustrated by one of his later engravings, the grotesque print, *Enthusiasm Delineated*. The original intention as he stated it was to show 'the strange effects of literal and low conceptions of Sacred Beings as also of the Idolatrous tendency of Pictures in Churches and Prints in Religious Books, etc.'. A second, much-altered version was retitled *Credulity, Superstition and Fanaticism, a Medley*. 'Enthusiasm', the eighteenth-century term of reproof for an excess

of emotion, was represented as unfavourably applying to the growing influence of the Methodists, who from the 1730s onwards made their effort to reach the ignorant and irreligious masses. The references to John Wesley and George Whitefield were plain to see, though the whole acrimonious collection of symbols round the fanatic figure of a preacher seemed equally to criticize papist doctrines and imagery and the zeal of the latter-day puritan.

In one surprising painting, surprising because without parallel in his work, Hogarth gave an extraordinary force to allegory. This was his *Satan, Sin and Death*. The subject, taken from *Paradise Lost*, was intensely dramatic as Milton conceived it and Hogarth's own sense of drama was fired by the poet's conception. Just as Milton described, so he painted the 'formidable shape' that 'seem'd woman to the waist, and fair, But ended foul in many a scaly fold'; 'The other shape, If shape it might be called' that 'shook a dreadful dart'; and Satan, 'that traitor-Angel' ready to fight Death, 'the grisly Terror', until the 'snaky sorceress' intervened reminded both how closely they were related.

Garrick, who acquired the picture, was well able to appreciate it as supernatural 'theatre'. In engraving *Satan, Sin and Death* made a strong impression on a later generation romantically receptive to the tremendous conflicts and defiances of *Paradise Lost*. For Hogarth it was an experiment more nearly related to his secular subjects, though in symbolic form, than to his thoughts of large-scale biblical history. It was a facet of his variety apt to be overlooked in too precise a definition of the 'modern moral subject'. There are other works, apart from the great series, with their dramatic procession of errant characters and distressing episodes, that simply give a slice of life with no moral attached. Pure comedy, though with that element of the calamitous that comedy contains, were the pictures of the distressed poet in his Grub Street attic and the companion piece of the musician outraged by the street noises outside his window. The *Four Times of Day* was a superb evocation of London buildings and street life, so faithful in 'Morning' to the atmosphere of Covent Garden and its church as they have since remained that their actuality keeps all the Hogarthian flavour.

Whether Hogarth had any purpose other than to convey a humorous zest in that marvel of animation and character, *The March to Finchley*, may be doubted. He could have had, perhaps,

some idea of showing how military order emerged from confusion in the distant view of disciplined troops marching off to the protection of London and its environs during the Jacobite rising of 1745, contrasted with the alcoholic leave-taking of the foreground stragglers. On the other hand he might have intended the contrast as an instance of the 'incongruity' that he regarded as the essence of humour. Only malice could accuse him of the treasonable motive that John Wilkes ascribed to him when the engraving of the work was published. By that time in any case the Jacobite rebellion was already a thing of the past.

The spirit of reform and the desire for improvement were nevertheless deeply rooted in Hogarth's active and restless intelligence. They led in two directions, one towards the improvement of art and the other the improvement of social conditions. In spite of asserting that the French were no colourists (a curious prejudice) and running down what he termed their 'foppishness' he must have felt that there was something to be learned from them and George Vertue was probably not beside the mark when he wrote in 1743, 'Mr Hogarth is set out for Paris – to cultivate knowledge and improve his stock of art'. For one thing he realized the superiority of French line engraving and went on the look-out for those capable of doing justice in reproduction to *Marriage à la Mode*. The skill of Baron, Scotin and Ravenet was to add its refinement to the prints published two years later.

It is only from Vertue that it is possible to gain an idea of Hogarth's second adventure across the Channel in 1748. His own account is brief and in various ways uninformative. The famous picture of Calais Gate, *O The Roast Beef of Old England*, tells part of the story in its compound of brilliant painting, insular prejudice and biographical record, evincing his dislike for what he saw of life across the Channel, a dislike heightened by his arrest as a supposed spy while sketching. The title, the refrain of a song in Fielding's early stage production, *Don Quixote in England*,

> When mighty roast beef was the Englishman's food
> It ennobled our hearts and enriched our blood ...

asserted the Georgian belief in sirloin as in some metaphysical way a symbol of island virtues in contrast with Continental poverty, slavery and superstition.

What Hogarth does not convey is why he went to France,

whether he visited a Salon, what paintings he might have seen and what he thought of them. From George Vertue's account of the visit, it would appear that he was one of a party that included the portrait painter Hudson, the 'drapery man' Van Aken and the sculptor John Cheere, as well as Hogarth's friend Hayman. In 1748 the Treaty of Aix-la-Chapelle brought war for the time being to an end and the peaceful interlude gave artists a welcome chance to travel abroad. Four members of the party made the most of it by going on from Paris to Flanders and Holland, visiting 'all the curious and famous artists in those cities where they went'.

For reasons unstated, Hogarth and Hayman did not go with them or stay long in Paris and according to Vertue both were arrested as spies on the way back. If he had stayed longer to take a serious look at the work of French contemporaries Hogarth might have realized that he was not so far from them in aim as he thought. His campaigns against dark pictures and the deliberate imitation of the darkening effects of time and varnish together with the freshness of colouring by which he put theory into practice place him aesthetically among the European masters of the century who banished technical gloom in favour of vivacity and clarity of style.

In a separate category were his ideas of social improvement and reform. The dramatic series involved morality as an inevitable consequence of treating subjects as a playwright would. Drama could not exist without reprehensible characters and distressing episodes, of necessity implying ideas of right and wrong, good and bad. It was almost impossible not to be, or not to be regarded as being, a moralist from this viewpoint. The active role of would-be reformer was a different thing, which Hogarth in his later years professed in several productions. His prints detailing the careers of the Idle and Industrious Apprentices, published when he was fifty, were, he avowed, 'calculated for the instruction of young people'. As such they were evidently considered suitable to be hung by parents where children could see them and to be given as a form of present that was also a salutary warning. No doubt it was for this reason, as Hogarth noted, 'these prints sell much more rapidly at Christmas than at any other season'.

Whether potentially bad boys were turned into good ones by the simple lesson in mercantile morality, not without its touch of smugness, seems less to the point than the magnificent panorama

of life he was once again able to achieve and the subtle irony that can be discerned in the equally boisterous acclaim that accompanies both Tom Idle on his way to execution and Lord Mayor Good-child in his civic splendour.

An increasing seriousness of social concern showed itself in the engravings of Hogarth's later years. The tippling of which he had often been the amused observer took an alarming form in the cheap raw spirits that in his time became the refuge of the poor. In the two companion prints, *Gin Lane* and *Beer Street*, published in 1751 when London had a multitude of gin shops, he intended to set out 'the dreadful consequences of gin-drinking that appeared in every street' and in contrast to extol 'that invigorating liquor' (beer) in the hope of driving gin 'out of vogue'.

Beer Street was perhaps too 'joyous and thriving' to be altogether convincing but *Gin Lane*, one of the great graphic masterpieces, that transformed the humbler regions of the parish of St Giles' into a fevered vision, transcended propagandist aim by its intensity. Propaganda had the force of a genuine indignation in the series that followed, *The Four Stages of Cruelty*. The humanitarian in the artist was aroused by 'the barbarous treatment of animals the very sight of which renders the streets of our metropolis so distressing to every feeling mind'.

The prints were intentionally explicit to the point of being horrifying and bold enough in style to grip the attention of the ignorant and brutal. He experimented with wood-engraving as being more forceful than the copperplate, though in the end he found force enough in his more habitual medium. There was much in real life to parallel invention. The scene of murder and arrest when Tom Nero has killed the pregnant servant girl who stole from her mistress on his behalf had its documented likeness in the Newgate records. Details, with which Hogarth was always and often humorously lavish, here had their sinister bearing on the theme. The scene in Surgeons Hall when the ruffian's corpse after his execution is disembowelled, is made the more macabre by the rope still remaining round his neck, the dog that gnaws his heart, the grinning skeletons of others who had met their end at Tyburn. Some found the pictures of tortured animals unbear-able to look at. Allan Cunningham, writing on Hogarth in his *Lives of the Painters*, wished the series had never been produced, so revolting did he find it. The prints were in fact more propaganda

than works of art though if they served in some degree to check 'the progress of cruelty' Hogarth, defiant as always of taste and aesthetic decorum, declared himself 'more proud of having been the author than I should be of having painted Raphael's Cartoons'.

The assertion, not especially relevant to Hogarth's greatness as an artist, brings into view an agreeable side of his character as a man, a readiness to bestir himself on behalf of the helpless – a description that applied to uncared for children as well as to animals. The support he gave to the Foundling Hospital and its philanthropic promoter, Thomas Coram, was to prove of more value and farther-reaching effect than might have been anticipated.

The creation or reconstruction of hospitals during Hogarth's lifetime relieves the picture of indifference to the health and welfare of the teeming urban world with a gleam of humanitarian light. Public subscription and the generosity of individuals and charitable bodies made improvements and new buildings possible. The bequest of Dr John Radcliffe not only gave Oxford the Radcliffe Infirmary and Observatory but made possible the rebuilding of St Bartholomew's Hospital in London. The wealth of the bookseller, Thomas Guy, largely gained from his investment in South Sea stock (prudently sold at the height of the boom), went to the building of Guy's Hospital. The hospitals built in the rural environs of the city, besides St George's and the Middlesex, included the Foundling Hospital established in what were then the meadows of Lamb's Conduit Fields.

The career of the founder, Thomas Coram, gives a remarkable instance of a growing philanthropy. Born in 1688 at the Dorsetshire seaport Lyme Regis, the son of a master mariner, Captain John Coram, he was intended for a seafaring life. He became a cabin boy on a merchant ship when about eleven years old. Later he was apprenticed to a Thames-side shipwright. When twenty-five he crossed to America and set up in business as a shipwright at Boston. He married there, prospered and began to interest himself in various benevolent projects. When General Oglethorpe founded the last of the English colonies, Georgia, named after George II, and intended as a refuge for the unfortunate and destitute, Coram was appointed one of the trustees. A good Anglican, he gave his support to the building of St Thomas's Church at Taunton, Massachusetts, and had thought to spare for the native

Red Indians. One of his plans was to promote a better understanding with them by establishing schools for Indian girls.

The sea-borne trade between England and the American colonies occupied him for some time as master of a merchant ship but he finally settled in London and found as many opportunities for good works as on the east coast of the North American continent. Frequent expeditions through the city's labyrinths made him painfully aware that infants were left to die in the gutters, that in general the pitiful condition of the unwanted child was a problem no one seemed to bother about. He organized a series of petitions to the King. His own petition in 1737 for a charter to found a hospital for their benefit stated the case forcibly. 'No expedient,' he then said, 'has been found out for preventing the frequent murders of children at their birth or for suppressing the custom of exposing them to perish in the streets or putting them out to nurses.' This latter alternative was also an abuse. Too often these baby-farmers 'undertaking to bring them up for small sums suffered them to starve, or if permitted to live, either turned them out to beg or steal or hired them out to persons by whom they were trained up in that way of living and sometimes blinded or maimed in order to move pity and thereby become fitter instruments of gain to their employers'. In these terms when the Royal Charter of Incorporation was granted in 1739 he addressed a large meeting of supporters, among whom was William Hogarth.

Both the man and the project appealed to the artist. What a contrast there was between this plain, honest merchant-captain bent on doing something worthwhile and the creatures of fashion with their futile purchases of bad foreign pictures. He, rather than they, deserved a portrait with all the symbolic accessories, not of empty grandeur but of a life well spent. In 1740, newly appointed one of the hospital's governors, Hogarth painted the portrait that is one of the century's landmarks.

With Hogarth's generosity and humaneness of spirit went his great confidence in himself and his abilities. Coram deserved his portrait but he, Hogarth, as he thought, was as well equipped to do justice to a full-sized likeness as any man past or present; certainly better than the foreign interloper, van Loo, and – why not? – as well as van Dyck! Allan Ramsay and the rest denied that he could. He would show them differently.

As it turned out there was little of Van Dyck in the result and

the refinement of that master's style might even have been out of place. There was more of the simple directness of Kneller (at his best) in the portrayal of Coram's homely and kindly features. The whole was a splendid variant of the baroque tradition but instead of accessories conveying grandeur, the unassuming attire, the terrestrial globe, the distant view of the sea, the hospital charter and seal, were more fitting to suggest the master mariner's useful career. By Hogarth's own account the portrait he painted with most pleasure, it was also the result of his determination to outdo his rivals. If this would seem an unworthy motive, he defied criticism by a vigorous defence of competition as 'one great source of excellence in all human attempts'. His analogy with the rider in a race or a boxer in the ring may not seem altogether appropriate as applied to art but the portrait, hung in a place of honour in the hospital, was to withstand the test of time as well as that of a temporary rivalry.

First housed in Hatton Garden, the Foundling Hospital was quickly seen to need more space. A public appeal for funds made possible the purchase of fifty-six acres of rural ground in Lamb's Conduit Fields. Not so large an acreage was needed but the owner, Lord Salisbury, would only sell the land as a whole. The hospital buildings, designed by Theodore Jacobsen, occupied a fraction of the area, with an allowance of ten acres for playing fields. As it turned out the unused acreage was to make a considerable addition to the revenue when the growth of London made the land of value for housing development. The new hospital buildings, completed in 1745, offered scope for decoration, of which Hogarth was quick to take advantage. He had previously shown his public spirit – allied to his wish to prove that 'history' was not beyond insular competence – in presenting his two vast Scripture stories to St Bartholomew's Hospital. At the Foundling he returned to the charge with a freer hand as Captain Coram's adviser. Architects, James Gibbs and others, had not been slow to give their services free of charge on behalf of so manifestly good a cause as the new hospitals. Hogarth was the first among the painters to do so. As it turned out he gained enthusiastic collaboration from others, rivals as some of them might be.

In 1746 three painters worked with him in providing a scheme of decoration for the Court Room, consisting of large biblical subjects, sympathetic in style and feeling to the charity and its

purposes. Hogarth's *Moses brought before Pharaoh's Daughter* set the key of sentiment that had its echo in Highmore's *Hagar and Ishmael*, the *Little Children brought to Christ* by the Rev. James Wills and *The Finding of the Infant Moses in the Bulrushes* by Francis Hayman. There would be little point in weighing these gentle narratives against the great works of history painting in the past. They could be regarded as succeeding admirably in the fitness of their themes to the institutional purpose and the grace with which they filled their allotted places in the interior.

A chance result of Hogarth's benevolence was the Foundling's acquisition of *The March of the Guards to Finchley*. The subject was in no way germane to the hospital's purposes, its humour a comment, when compared with *Moses brought before Pharaoh's Daughter*, on the difference between the artist in spontaneous mood and on the polite behaviour due to an essay in 'high art'. His unconventional way of disposing of his paintings by lottery in this instance assigned 167 unsold tickets of the 2,000 total to the Hospital. It so happened when the draw took place in 1750 that the winning ticket was among them. The gamble provided the charity with a masterpiece.

However he might complain on other occasions of the 'buzzing of hornets' (his fellow artists) Hogarth had no lack of co-operation in this charitable enterprise. Painters followed his lead with a shower of gifts, no doubt with some satisfaction at receiving the honorary title of Governer of the Hospital in return. The landscape men gave works that were suitably topographic — Richard Wilson, a view of the Foundling Hospital seen across the fields, as well as of St George's Hospital in its rural setting; the young Thomas Gainsborough his roundel of the Charterhouse.

Portraits of those in some way connected with the Hospital were many in addition to Hogarth's *Captain Coram*. Thomas Hudson contributed a likeness of the Foundling architect, Theodore Jacobsen, holding a drawing of the West Front; Allan Ramsay a fine full-length of the renowned Dr Richard Mead, George II's physician and one of the Hospital's original governors; Highmore a dignified portrait of another of the original owners, Thomas Emmerson, wealthy sugar-broker in Thames Street, who left the Hospital £12,000 in his will.

Other arts made their contribution. The decorative plasterwork of William Wilton, father of the sculptor, Joseph Wilton, added

to the elegance of the Court Room. Sculpture was represented by Rysbrack's marble relief *Charity Children engaged in Navigation and Husbandry*, set in the carved frame designed by the master mason John Deval, who had taken part in the construction of the building.

Music was to be a cardinal feature of the Hospital's history. Handel gave the organ in the Chapel, often played on it himself, composed the Foundling Anthem and conducted performances of *The Messiah*. The yearly production of one or other of his oratorios became a tradition continued in modern times. Before Thomas Coram died in 1751, the home for unwanted children had in a quite magical fashion taken on the unexpected, supplementary character of an art centre. The roll of governors, not confined to doctors and benevolent men of business, was also a list of the most celebrated artists of the time. The combined attractions of music and painting made the Hospital a meeting-place for fashionable London. The picture provided the first of public exhibitions of a selective kind and apart from the miscellanies of the auction rooms. Gone from Bloomsbury since 1926 is the eighteenth-century building, but the later headquarters in Brunswick Square of the charity, renamed in 1954 the Thomas Coram Foundation for Children, retains the works of art originally acquired and reconstructs for the visitor the enthusiastic meeting-point of art and social life in the 1740s.

~~ 16 ~~

Troubled Years

It was in 1749 that Hogarth and his wife, taking with them Judith, Lady Thornhill and Hogarth's sister, Ann, established themselves in a country house near the Thames at Chiswick as a summer alternative to the house in Leicester Fields. Unintentionally the move brought them near to Lord Burlington's Palladian villa, emblem of the 'Taste' Hogarth had lampooned, with its decorations and gardens by William Kent whom he regarded with so much scorn. Yet in the eighteenth century the delightful stretches of country along the curves of the river from Hammersmith to Hampton, of which Chiswick was one focal point, had the attraction of unspoilt nature – the more tempting to the painter and man of letters, to Kneller, to Pope, to Horace Walpole, to David Garrick too, from being not very far from town. Here was a peaceful contrast to London where, it might be thought, Hogarth in his later years would relax in comfortable domesticity, the financial ease his prints had provided and the satisfaction of great works already achieved.

In fact he was more than ever restless, disturbed by events in his world, touchy and resentful of criticism that he magnified into persecution, whimsical in expressions of defiance. Summer months spent amid green fields and riding on horseback along the river did nothing to allay the unrest that drove him into a variety of effort.

A defiant humour always marked his announcements of works to be sold and his unorthodox methods of disposing of them by auction or lottery – which were almost uniformly disappointing in result. Swift's *Battle of the Books* may have inspired the *Battle of the Pictures*, the ticket of admission to the auction of the six

99

Marriage à la Mode paintings in 1744, with its engraving of an encounter between an army of Old Masters and his own paintings. A regiment of copies of such subjects as Europa and the Bull, the Flaying of Marsyas and St Andrew on the Cross stood in waiting to launch their attack while aggression in the forefront launched the *Aldobrandini Marriage* against the second scene of *Marriage à la Mode*, still on its easel. A St Francis at Prayer slashed across the 'Morning' of the *Four Times of Day*, a Penitent Magdalen tore a hole in *A Harlot's Progress*. Hogarth's canvasses fought back, the Rake's orgy inflicting punishment on Titian's *Feast of Olympus*, the *Midnight Modern Conversation* on a Bacchanal.

Prospective buyers were not amused. The pictorial mêlée was more ingenious than creative of sympathy for Hogarth's aims. Nor were buyers attracted by the mode of bidding, which entailed writing on a slip of paper what the bidder was prepared to offer and waiting a month, during which the paintings were on show at Cock's auction rooms for the highest offer to be made known. Only one was forthcoming, from a Mr Lane of Hillingdon. Vertue, who thought it, understandably, an extraordinary manner of conducting business, noted that 'The sale so mortified Hogarth's high spirits and ambition that it threw him into a rage and he cursed and damned the public and swore they had all combined together to oppose him'. The day after 'in a pet' he took down the sign, the Golden Head, the emblem of an artist's dwelling, from above his door.

Restlessness of mind made for variations of aim both in paintings and engravings, magnificent prints alternated with the grotesque. The propagandist purpose, transcended in that summary of human misery, the *Gin Lane* of 1750, was still in his mind when in 1751 he produced another work as powerful in his engraving *The Cockpit*. A renewed attack on cruelty and the gambling that in this instance was its accompaniment, it was raised to the level of grandeur as a work of art by the intensity of expression and movement in the ferocious groups on either side of the central pathetic figure, identified as the blind Lord Albemarle Bertie, and the groups in the foreground completing the ring round the fighting birds.

The seriousness and profound implications of such a work contrast with the pictorial oddities of which the *Five Orders of Periwigs* is an example. This was a joke at the expense of James

('Athenian') Stuart and his concern with the exact measurements of the classical orders of architecture, part of the research that was to go into the published *Antiquities of Athens*, already announced when Hogarth etched his print. It was not a particularly good joke but a characteristic ridicule of anything so far outside his ken or sympathy as the Greek revival in architecture of which Stuart was a pioneer.

Hogarth's attitude to the classic past and the grand manner of history painting remained strangely compounded of respect and disrespect. He could not resist the challenge of the commissions offered him in his later years, or carry them out with the immense verve of the Election series, produced in the same period. The *Paul before Felix* commissioned for Lincoln's Inn and the subscription ticket made for the engraving from the painting in 1751 make a strange mixture of intentions. The example of Raphael's Cartoons suggested a subject from the Acts of the Apostles and a composition similar to that of Raphael's *Paul Preaching at Athens*. The engraving associated with it became a parody, 'drawn and etched in the true Dutch taste', of what Hogarth described as 'the ridiculous manner of Rembrandt', a seeming irrelevance that leaves one to wonder whether he intended to exalt Raphael as a model at Rembrandt's expense – or indeed whether some latent irreverence for the whole enterprise of history painting had not suddenly come to the surface.

Not long after he had completed one more commission to order, the altarpiece for St Mary Redcliffe, Bristol, he declared his intention of giving up history painting and returning to portraiture, producing no more prints for the time being. The change of front was the opposite of that which had earlier led him to give up rivalry with the phizmongers and address himself to the general public in his prints. He could now count on a demand. 'Hogarth,' wrote his friend Benjamin Hoadly in 1757, 'has again got into portraits and has his hands full and at a high price.' In the position of financial independence he had gained he could please himself in both his choice of sitters and his style. He showed the capacity to generalize, to bring out an essential humanity rather than to dwell on individual peculiarities that he had already shown in the superb sketch, the *Shrimp Girl*. In the group of his servants' heads, painted as a domestic record simply, it was one of his major triumphs; progress from youth to age, as well as the Englishness

of character so truthfully conveyed, made the picture a grandly philosophic reflection on human life.

In other portraits the restlessness of these years appeared in variations of method: 'The life must not be rigidly followed,' he wrote. His effort to avoid the monotony of phizmongering did not lead to that close scrutiny of the individual by which Joshua Reynolds was to make his contemporaries of the Literary Club instantly and eternally recognizable. With a playful experiment in style he painted Garrick and his wife somewhat after the manner of van Loo, with 'not so much fancy as to be affected or ridiculous' John Hoadly (the brother of Benjamin Hoadly) thought, but perhaps with too little of the formal portrait, too much an air of actors in an allegory of domesticity to please Garrick himself – quite apart from the difficulties encountered in the painting of his eyes.

With another change of manner he painted the engraver John Pine after the style of Rembrandt, that master whom he seems to have regarded with a mixture of admiration and irreverence. Pine had been the model for the fat friar in *Calais Gate,* gaining the nickname subsequently of 'Friar Pine' – for which his portrait in Rembrandtesque guise can scarcely have been compensation. In other ways Hogarth was more seriously occupied. Difficult and disturbing matters loomed large. The nature of beauty was a question over which he pondered long and earnestly. He once again became a centre of controversy with a picture, *Sigismunda*, painted in challenge to the vogue for Italian art. He plunged into opposition to the efforts to found a Royal Academy. He allowed himself to become embroiled in political dispute. They occupy a disproportionate space in his autobiographical notes, though this indicates the extent to which they had come to occupy and prey on his mind.

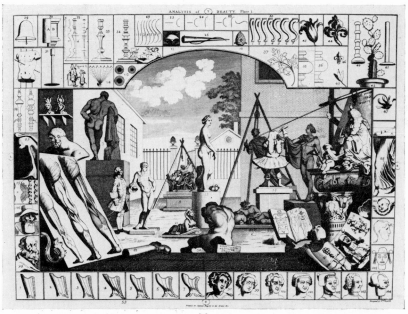

28 *The Analysis of Beauty*, 1753, Plate 1: *Cheere's Statuary Yard*

29 *The Happy Marriage*, VI, 'The Dance', *c.* 1745

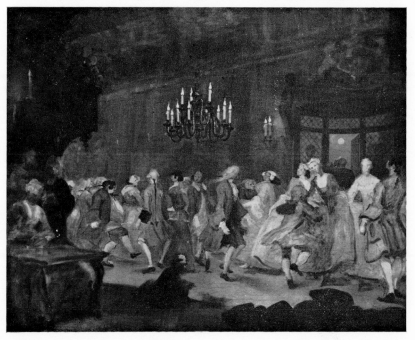

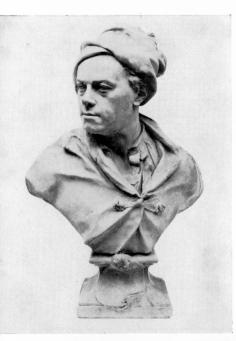

30 Louis François Roubiliac, bust of Hogarth, *c.* 1741

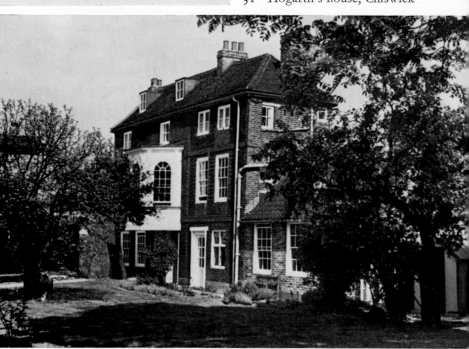

31 Hogarth's house, Chiswick

17

The Nature of Beauty

His cap pushed back, the youthful scar plain to see on his brow, Hogarth gazes at the spectator in the medallion self-portrait he painted in 1745, with something of an expectant air, as if to say, 'What do you make of this?' The volumes beneath, of Shakespeare, Milton and Swift, declare his allegiance to, his association with, national greatness. Beside him, his pug dog Trump, licking his chops, seems ready like his master to take on all comers. To one side is the artist's palette on which is traced a curving line with the inscription 'The line of Beauty'.

What was the meaning of this curious hieroglyph? Curiosity became general when the portrait was engraved in 1749 as a frontispiece to a collected edition of his prints. The bait, to use his own metaphor, was swallowed. Painters, sculptors and many people more pestered him for the answer. The explanation was given four years later in the book, 'printed for the author by J Reeves and sold at his house in Leicester Fields', *The Analysis of Beauty*, as remarkable and original a work as might be expected from one of Hogarth's independence of mind and vigour of intelligence.

He went directly to the heart of the problem, rejecting any attempt to base it on moral or literary associations and boldly defining the principles of a purely visual language. Variety was the essence of his definition; and variety was best exemplified by forms of curvature—the serpentine line as it might be drawn on a plane surface, the 'line of Beauty' and its equivalent, in three dimensions, the 'line of Grace' to be imagined as the track of a wire wound round a cone. The same principle of variety applied to the disposition of colours as well as form. Variety and intricacy

produced the agreeable sensation of leading the eye 'in wanton chase' – 'wanton' in no way suggesting 'dissolute' but a free and informal movement giving visual pleasure.

'Line' as he used the word did not mean a definite outline drawn round objects. A true painter, he avoided in his own practice any such linear convention. In drawing he worked as the masters of oil painting have been apt to do, with broken touches suggesting the eventual arrangement of mass and colour in paint. Line in his engravings and etchings was the subordinate means of rendering light and shade by elaborate shading. In this there is no contradiction of his theory. Variety did not exclude the idea of the 'joint sensations of bulk and motion'. The lines of Beauty and Grace were underlying factors, the implied track of a movement unifying and animating a whole composition. It can be traced in fact in many of his social scenes, the orgy of *A Rake's Progress* for example.

Somehow Hogarth managed to make clear a general trend in European art after the Renaissance and from the sixteenth century onwards, a trend away from classic symmetry that took its way through all the variations of curvature, monumental in baroque painting, elegantly vivacious in the more intimate form that the term 'rococo' serves to define. There was a baroque background to Hogarth in what he could learn from Thornhill and from the decorative modes of silverplate engraving, still apparent in his essays in 'history painting'. He turned in his own way to the rococo direction in the great comedies. The *Analysis* was unique as an exposition of the 'composed intricacy of form' in which he was instinctively at one with great Europeans of the time from Watteau to Tiepolo, little though he may have known or cared about any such historical sequence in countries of which in general he had a rooted suspicion. At the same time he laid stress on 'nature' as the supreme exemplar of variety, nature being understood to comprise every kind of visible form from plants to human beings. The numbered details of his illustrations gave concrete point to his theoretic statements.

The radical argument of the *Analysis* caused a stir when it appeared. It was a brusque departure from what he called 'the strange way in which this subject has been treated by preceding writers'; the confusions of philosophers who rambled at large, the parade of knowledge of travellers who had made 'a hasty

journey through Europe', the rules laid down in the treatises of painters on painting. Edmund Burke was to record his debt to the 'ingenious Mr Hogarth' of whose ideas he made liberal use in the *Enquiry into the Nature of the Sublime and Beautiful*. French, German and Italian translations followed at intervals and the *Analysis* made impression enough to be attacked by Diderot in France and praised by Lessing in Germany. Those who liked the book least in England were the painters.

The 'hornet's nest' of those offended by his outspokenness buzzed again. In particular the artists busy with efforts to found a Royal Academy resented the ridicule Hogarth poured on the scheme. His venture into print was an occasion on which to get their own back. A leader among his assailants was one of the younger generation, the pioneer in topographical watercolour, Paul Sandby. He and his brother, the architectural draughtsman, Thomas Sandby, were inclined to favour an official establishment such as the projected Academy by reason of the official employments both had found. Two ambitious youths from Nottingham, they came to London in 1742 and were taken on in the military drawing department at the Tower. Paul at the age of twenty profited by this position to apply successfully for the post of draughtsman to the military survey in Scotland that followed the suppression of the '45 rising. Thomas secured the appointment of Deputy Ranger of Windsor Great Park through the interest of William Augustus, Duke of Cumberland, for whom he acted as secretary and draughtsman. His brother stayed with him at the Ranger's Lodge, where he began to specialize in watercolour landscape. Aware of the benefits of organized effort and official support, Paul Sandby became an active member of the Society of Arts founded in 1754 and an energetic promoter of plans for a Royal Academy. He strongly resented Hogarth's saying that these plans 'deserved to be laughed at'. The publication of *Analysis of Beauty* gave him the opportunity to laugh in return at Hogarth's expense.

Sandby, the author of so many pleasant country views, had a bent for caricature also. The kindness of heart for which he was frequently extolled was little apparent in the etched series in which he sneered at the attempt to define beauty of one whom he made out to be incapable of producing anything but ugliness. He portrayed Hogarth with the hind legs of his favourite pet and symbol,

the pug dog, at work in a studio where shutters, each bearing the name of a famous master, excluded the light they were capable of giving. An especially gross caricature of 1754, entitled *Puggs Graces*, depicted a group of grotesquely misshapen female models, in burlesque of the artist's conception of Elegance and Grace. Nondescript numbered objects parodied Hogarth's method of illustrating his text. A satyr, holding up a mirror, reflected him in a fool's cap and with ass's ears. A portly gentleman, seeming to direct his hand and bearing some resemblance to Dr Benjamin Hoadly, suggested plainly enough that Hogarth as a writer depended on others.

These and other burlesques were perhaps more upsetting to Hogarth than they need have been. He took their gross humours seriously enough to describe himself as 'pestered with caricature drawings and hung up in effigy in prints; accused of vanity, ignorance and envy; called a mean and contemptible dauber; represented in the strangest employments and pictured in the strangest shapes ...' The satirist was as vulnerable as others when it came to being satirized.

Other troubles loomed. Though Sandby picked on the *Analysis* for ridicule the underlying reason for his attack was Hogarth's opposition to the founding of a Royal Academy. Many artists besides Sandby favoured the proposal. Hogarth's objections ran counter to the wishes of friends and enemies alike, as well as of a younger generation eager to make their work known. By a long-drawn-out, devious and yet inexorable process the idea took various shapes before reaching its eventual fruition four years after his death.

18

Tangles of Dispute

The artist-governors of the Foundling Hospital dined there each
year. On that occasion in 1759 Francis Hayman broached the idea
of founding 'a great museum all our own', to begin with a series
of public exhibitions. The success of the Foundling's display of
pictures was an encouragement to take this practical step while a
more permanent union was still being considered. For a long time
past the hard lot of painters dependent on picture dealers for a
pittance had been a cause of complaint. For a while it appeared
that the professionals might usefully join with a body generally
interested in the promotion of the arts such as the Society of
Dilettanti. Mainly consisting of wealthy amateurs who had visited
Italy on the Grand Tour, 'persons of quality, nobles and gentle-
men' as George Vertue described them, the Society included a
number of artists.

The negotiations begun in 1755 by Hayman and others fell
through. The stipulation that the president of the intended Royal
Academy should always be chosen from the Society of Dilettanti,
which should also command a majority of votes, was little to the
artists' liking. The conviviality of the members, whom George
Knapton portrayed in fancy dress and with a variety of wine
glasses to hand, serious as their interest in classical archaeology
might be, did not augur that special concern with the living artist's
problems that was urgently in the minds of Hayman and his
fellows. Remote possibility as it might be, the thought was scarcely
to be entertained that so flighty a Dilettante as that merry 'Monk
of Medmenham', Sir Francis Dashwood (pictured by Knapton as
a gowned friar gazing at the Medici Venus), could become
President.

So the problem remained. The Academy in St Martin's Lane was a training ground but not an exhibition centre. The auction rooms, the only public galleries, were, as the Swiss miniaturist Roquet remarked, when writing his account of *The State of the Arts in England* (1755), 'traps for the ignorant' in the shape of those old dark canvasses hopefully given impressive attributions, against which Hogarth inveighed. There was indeed the splendid beginning of 'a Museum of our own' in Sir Hans Sloane's great collection acquired for the nation after his death in 1753 at the age of ninety-three, but this nucleus of the British Museum was not at all the 'museum' Hayman had in mind. Its immense hoard of antiquities and natural history specimens, of the highest value for general enlightenment, served no immediate purpose for painters. A step forward was to launch an annual exhibition, the first being held in 1760, the year of George III's accession, in the premises of the Society of Arts. This body, founded 'for the Encouragement of Arts, Manufactures and Commerce', had established its own practice of awarding prizes for paintings and drawings and exhibiting work of the successful competitors. Some confusion now appeared as the paintings of guest exhibitors were hung among those of the Society's award winners. This, it was supposed, could leave the wrong impression that the visitors had failed to secure premiums for which in fact they were not candidates.

The exhibition was a success, as may be judged by the sales of 6,582 catalogues, but as the Society of Arts refused to alter its practice, a split followed. The 'Society of Artists' that held a second exhibition at Spring Gardens in the following year was a separate organization. More dissension was to follow. 'The Free Society', another offshoot of the original exhibition, opposed itself to the Society of Artists. Some years had to elapse before the Royal Academy at last came into being, yet through all dissension there was a continued impetus towards that end – which was also the beginning of a fresh chapter in the history of British art. Founder members-to-be were the artists joined together in the Society of Artists of Great Britain who assembled over dinner at the Turk's Head Tavern in Gerrard Street in 1763 to give final definition to their plans. Their banquet of carp and soles, ox head, marrow pudding, goose, and beefsteak pie, washed down with copious draughts of wine and porter, was the prototype of the annual Academy banquets to come. Francis Hayman, Richard

Wilson, Paul Sandby and the already much-esteemed Joshua
Reynolds, whose exhibits attracted special notice, were of the
company. Hogarth was not one of them. By 1763 he was an ailing
man with only a year to live and in any case out of sympathy with
a changing art world and the attempts to give it an official image.

His opposition had long been made plain. What was the need
for a Royal Academy? Had not the academy in St Martin's Lane
with which he had so long been associated done well enough in
its free and easy way? Anything more, he asserted, would only be
of use to those 'who are to be elected professors and receive
salaries'. The possible alliance with other societies was suspect.
The Dilettanti with their airs of aristocratic superiority wished to
persuade the world that no genius could exist without their
sanction. He had little hope of 'design' as interpreted by the
Society of Arts and Manufactures. 'How absurd it would be to
see periwig-makers' and shoemakers' boys learning the art of
drawing that they might give grace to a peruke or a slipper.'
Always a dissident he approved of the breakaway of the Spring
Gardens exhibition in 1761 for which he designed the catalogue
frontispiece and tailpiece. The frontispiece depicted Britannia
watering the trees of Architecture, Sculpture and Painting, the
last-named being the least flourishing. The tailpiece lampooned
an affected connoisseurship in the form of a fashionably attired ape
also with a watering can but seeking to nourish the withered
stumps of foreign reputations that belonged to the past. Hogarth's
Sigismunda was one of the exhibits – and thus arose another storm,
provoked by this famous and much-abused picture mixed with
other causes of controversy.

The circumstances were detailed at some length by Hogarth to
explain how badly he was treated. He had an enthusiastic admirer
in James Caulfield, fourth Viscount Charlemont (and first Earl of
Charlemont from 1762), a prominent figure in Anglo-Irish society
and in later years an advocate of Irish independence. This 'amiable
nobleman', whose amiability can be discerned in the portrait
Hogarth painted when Charlemont was about thirty, pressed him
to paint a subject picture, leaving him a free hand as to the theme
and price to be paid. The result was *The Lady's Last Stake*,
designed in that vein of rococo gallantry that Charlemont was
likely to appreciate. The spectator was left to wonder whether the
lady 'young and virtuous' would take back the money, watch and

jewels she had lost at cards to a young officer, 'in return for her honour'. The patron was well pleased with the amorous dilemma thus presented and to that point all was well, but it happened that the wealthy Sir Richard Grosvenor, who saw the picture, was sufficiently taken with it to ask for another subject of Hogarth's own choice. This was where trouble began.

Instead of another trifling subject Hogarth chose the story from Boccaccio, retold by Dryden, of Sigismunda weeping over the heart of her dead lover, Guicciardo. It was Hogarth's wish to 'fetch a tear from the spectator'. A secondary motive was to rival a painting of the same subject, recently sold with a hopeful and mistaken attribution to Correggio but in fact by a minor Florentine painter, Francesco Furini. Hogarth worked hard on his version but by the time it was finished, in 1759, Sir Richard Grosvenor's enthusiasm had cooled. It may be, as Hogarth thought, that meanwhile he 'fell into the clutches of the dealers in old pictures' who put him off. At all events Grosvenor backed out of the arrangement on the ground that the subject was too painful to live with. 'I kept my picture – he kept his money,' said Hogarth. He sent the work to the Spring Gardens exhibition in 1761, where it met with execration, loud and long continuing.

A complex of animosities was aroused – against Hogarth the would-be history painter, the enemy of 'Taste', the author of unwelcome opinions – rather than serious consideration of the picture itself. Now was the time, he said, 'for every little dog to bark in their profession and revive the old spleen which appeared at the time my Analysis came out'. Those who could mistake a Furini for a Correggio were not deterred from ridiculing Hogarth in comparison. Though Horace Walpole wrote about Hogarth after his death, on the whole in admiring terms, his comments on *Sigismunda* could be taken as an example of the contemporary outcry. 'It was,' said Walpole, 'the representation of a maudlin strumpet just turned out of keeping, and with eyes red with rage and usquebaugh, tearing off the ornaments her keeper had given her.' A pretty comment to make on the refined countenance, reputedly of Mrs Hogarth, as her husband had seen her in grief at the death of her mother!

'To add,' Walpole went on, 'to the disgust raised by such vulgar expression, her fingers bloodied by her lover's heart that lay before her like that of a sheep for her dinner.' This would more aptly

apply to Furini's version; and Walpole's memory of the Hogarth is of doubtful accuracy. No trace of the bloodstains has remained on the fingers nor is Guicciardo's heart so gruesomely displayed. He and other critics saw what they chose to imagine without looking. The story is told of a madman visiting the exhibition who said he could not bear 'those white roses', meaning Sigismunda's sleeves. At least he used his eyes and Hogarth seems to have taken notice of the remark to the extent of modifying the whiteness of the folds.

Offended by the treatment of what was certainly a handsome enough piece of pictorial drama if not one of Hogarth's masterpieces, he withdrew the picture before the Spring Gardens exhibition ended, replacing it by 'Chairing the Member' from the Election series. Enmity was kept alive in the following year by the Sign Painters Exhibition, organized by the witty man of letters, Bonnell Thornton, promoter of the 'No Nonsense' Club, who specialized in ridicule. Hogarth's interest in the primitive and popular art of the sign painter, apparent in many a street scene, associated him with the venture.

Thornton, as Boswell records, could amuse Dr Johnson by a burlesque 'Ode on St Cecilia's Day', 'adapted to the ancient British musick, viz. the saltbox, the jew's harp, the marrow bones and cleaver, the hum-strum or hurdy-gurdy, etc ...' His collection of sign paintings failed to amuse the touchy professionals of painting. The exhibition was taken as an affront to the Society of Arts, Manufactures and Commerce and blame was attached as much to Hogarth as to Thornton's supposed frivolity.

In this season of attacks and counter-attacks, Horace Walpole made Hogarth's personal acquaintance for the first time. The third son of Sir Robert Walpole in 1761 was a slender, pale, dark-eyed, middle-aged bachelor – much as he appears in the portrait by the German-born painter, John Giles Eckhardt, the 'modest worthy man' for whom he gained many commissions from among his family and friends. Though his father, the first Earl of Orford when he died, had left debts rather than fortune, Horace was comfortably off from the proceeds of various sinecures. Eton, Cambridge, the Grand Tour, the round of social pleasure and experience of politics as a member of parliament had all contributed to his development. His father's collection had first incited him to write about art, in 1743, when he compiled his catalogue

of the Houghton pictures, *Aedes Walpolianae*, with lively and sometimes rash expressions of critical opinion. Antiquarian taste led him to reconstruct his small house at Twickenham, Strawberry Hill (within sight of Pope's villa) into the semblance of a miniature 'Gothick' castle, crowded with small objects of art and *vertu* – a fantasy that was to turn into the romantic dream of his novel, *The Castle of Otranto*. Of especial interest to Walpole was the work of George Vertue both as antiquary and chronicler of painting.

When he met Hogarth, he was completing the revision, reshaping and amplification of Vertue's notebooks which he had bought in some forty MS volumes for £100 from the engraver's widow some years before. The first part of the resulting *Anecdotes of Painting in England*, in which Hogarth was later to have his important posthumous place, was well on the way to publication. The fastidious Walpole, with all the studied calm proper to a gentleman, as was then correct deprecating any outward display of 'enthusiasm', was taken aback by Hogarth's vehemence. Outbursts against the 'miscreants', 'cheats' and 'venders of poison' that he saw on every hand raised a doubt in his self-possessed visitor's mind as to the artist's sanity. 'I hope,' was Walpole's reflection, 'that nobody will ask me if he was not mad.'

Sane enough, though much embittered and in poor health, Hogarth was now certainly ill-advised in attempting a foray into politics, from which he had hitherto kept clear. In 1762 he published his engraving *The Times* which earned him the enmity of two formidable adversaries in John Wilkes and his ally, Charles Churchill. His intention was not entirely altruistic. After months of illness that the *Sigismunda* affair had helped to bring on and in fretful convalescence at Chiswick, he felt the need 'to do some timely thing to stop a gap in my income'. He hoped, more idealistically, that the print would tend to peace and unanimity, though whether the spectacle of immense confusion that he conjured up in his inimitable fashion was calculated to further this end might be a question. *The Times* was a comment on the political situation towards the end of the Seven Years' War which the far-reaching plans of William Pitt had turned into a series of decisive victories with vast gains overseas. A complication was the attitude of the young George III, indoctrinated by his mother, the Dowager Princess, and her reputed lover, John Stuart, third Earl of Bute, with the idea of absolute monarchy. Bute was therefore bent on

destroying the dominance of the Whigs and especially the autho-
rity Pitt had gained. It was necessary on both counts to wind up
the wars with France and dismiss the Whig ministers that had
conducted it. The Tory Earl was the royal instrument and
appointed minister.

Feeling, especially in London, was aroused against 'petticoat
government' — as instanced in the Princess's admonition, 'George,
be King'; against the Earl of Bute as a Scot, considered to be pre-
judiced in favour of his fellow countrymen; against the intima-
tions of a revived despotism. Opposition had a mouthpiece in
John Wilkes. The son of a London distiller, introduced into the
fashionable and dissolute circle of Medmenham by Sir Francis
Dashwood, Wilkes entered the political arena as a supporter of
Pitt and in 1757 member of parliament for Aylesbury. He had a
personal grievance against Bute, who refused to make him an
ambassador or a colonial governor, and this animosity was vented
in the weekly journal he started in 1762, the *North Briton*, in
answer to *The Briton*, the paper edited by Smollett on behalf of the
Bute ministry.

Wilkes put into practice his precept for public speaking, 'Be as
impudent as you can and as merry as you can' and had a henchman
as adept in the poet, satirist and ex-parson, Churchill. The *North
Briton* was an instance of the growing power of journalism. They
were only incidental targets in Hogarth's print, which was mainly
a defence of Bute as one trying to prevent the extension of war and
restore peace. Pitt, pictured on stilts that symbolized his assump-
tion of too great authority, fanned the flames of war in Germany,
France and Spain that the ministerial fire brigade was trying to
put out. Wilkes and Churchill were to be seen at attic windows
sniping at the head fireman, the Earl of Bute. Urchins got in the
way of the water carriers with barrow loads of the *North Briton* to
feed the conflagration. But Hogarth had put his hand dangerously
near to the political buzz-saw, as his friend Garrick perceived.
Garrick remarked that the print was harmless enough, had 'enter-
taining stuff in it' and urged Wilkes to take no hostile action, but
in vain. Wilkes, previously on friendly terms with Hogarth, was
prompt to dispose of him as an extra antagonist who had volun-
tarily got into the fray.

He and Churchill were well practised in abuse. In the *North
Briton*, Hogarth, Sergeant Painter to the King since 1757, was

condemned as the lackey of royal policy. Wilkes sneered at 'the *supposed* author of the *Analysis of Beauty*', an unfair distortion of Hogarth's acknowledgment of the help received 'from one or two friends' which in fact amounted to no more than a few verbal improvements and the addition of a few classical references. Churchill wrote his venomous 'Epistle to William Hogarth' claiming the role of martyr.

> Hogarth a guilty pleasure in his eyes
> The place of executioner supplies ...

Sandby joined in with more caricaturing and a political pun on 'the line of Buty'. 'Never,' said Walpole of the whole affair, 'was more mud thrown with less dexterity.'

Hogarth's sequel to *The Times* (unpublished until many years after his death) was more diffuse in incident, though he did not fail to draw Wilkes in the pillory alongside that phantom celebrity of the day, Fanny, the Cock Lane Ghost. More devastating was the portrait, etched from a drawing in 1763 at the time when Wilkes was arrested on a general warrant for criticism of the King's speech in No. 45 of the *North Briton*. Hogarth gave Wilkes the same look of the outlaw as Lord Lovat. Without obvious caricature, the portrait with its stress on Wilkes's squint became the personification of slyness and malignancy, the cap of liberty held up at an insolent angle the emblem of rabble-rousing. Churchill, the 'toad-eater' as Hogarth described him, got off more lightly as 'The Bruiser', in the guise of a bear with a foaming tankard, the tattered remains of clerical neckwear and a club knotted with the word 'Lies'.

Hogarth professed to have gained some satisfaction from the encounter, though it was a passing episode in Wilkes's stormy career. Many battles were still to be fought, from which he emerged as a popular hero, the defender of electoral freedom and ten years after Hogarth's death, Lord Mayor of London. In the notes the artist put together towards the end of his life, the controversy then fresh in mind and other recent causes of annoyance or distress were rankling issues. They took up much room in the manuscript eventually used by John Ireland in the biographical supplement to his *Hogarth Illustrated*, published in 1798 (a work to be distinguished from the *Graphic Illustrations of Hogarth* by the engraver, Samuel Ireland). A former watchmaker in Maiden Lane, occasion-

al author, collector of books and prints and Hogarth's staunch admirer, John Ireland assembled the drafts that formed an auto-biographical fragment. They left many gaps as regards Hogarth's early experience, the people he knew, his affections, his predilections among artists. They enlarged upon his objections to an academy, the criticisms of the *Analysis of Beauty*, the fate of *Sigismunda*, the attacks of the *North Briton*. The spirit of defiance that pervaded his writing was summed up in the 'No Dedication', perhaps originally intended for the *Analysis*, which Ireland reproduced in facsimile as a frontispiece to the supplement of *Hogarth Illustrated*. This negative assertion denied acknowledgment 'to any Prince in Christendom ... any Man of Quality ... any Learned Body, any Particular Friend (for fear of offending another)', was 'Therefore Dedicated to Nobody' – a bitter way of saying his work was for all.

19

A Changing World

In the last years he was much occupied with the thought of Time and its effect. Time as a destructive agent was the subject of the subscription ticket he had prepared for the projected engraving of *Sigismunda*. The symbolic figure, seated on a mutilated statue, tears a canvas with his scythe, blows on it clouds of darkening smoke, with a pot of varnish at hand to help the process. Time was the subject of his final print, *The Bathos*, pessimistic in spirit but, as ever, marvellous in invention. More than prescience of his own end, the print projected the end of art, the end of time itself, the vanity of life. With all the force of accumulated detail he had given to his pictured tales he engraved an ultimate devastation. Propped against graveyard ruins, Time with clipped wings, broken scythe, hourglass and pipe breathes out 'Finis' in a final puff of smoke. A bow unstrung, a shattered gun, a cracked bell, a broken palette, the derelict sign of the World's End tavern, the play script with the direction 'Exeunt Omnes', the chariot of Phoebus Apollo halted in mid-air; combined in a valediction that, gloomy as it seemed in purport, lacked nothing of the liveliness and even the humour he had lavished on the details of his social scenes. He must have enjoyed devising this apocalyptic farewell. The print was published in March, 1764.

By then Hogarth had made some recovery from the stroke that had disabled him the year before. He was well enough to do some revision on his prints, and still pondered how he could best make clear that difference between 'character' and 'caricature' that had always been in his mind. He worked on his engraving of *The Bench*, the powerful conception of legal pomp and personality as represented by the justices of the Court of Common Pleas, that

he had painted some years before. An unfinished line of comic heads disturbed the magnificence of the print with the effort to show how 'character' might degenerate into absurdity. He was thus occupied the day before he died, on October 26th, 1764, after being taken from Chiswick back to his house in Leicester Square.

A new world of art was coming into being different from that through which he had taken his heroic and hostile way. If portraiture was still a labour enforced by a constant demand it was now to reach its most brilliant level. While Hogarth lay on his deathbed the house of Joshua Reynolds on the western side of Leicester Square was already the rendezvous of the fashionable and intellectual world his portraits were to immortalize. At Bath the star of Thomas Gainsborough was in the ascendant. Relief from the limitations of portraiture was no longer sought mainly in the 'grand style' of subject. Country life, so little within Hogarth's ken, fostered a variety of genres. The tastes of a sporting and landowning aristocracy included the desire for pictures of their mansions, estates and rural diversions. A sporting school reached its zenith in George Stubbs. The farm and the cottage had a chronicler such as George Morland. Landscape passed through its splendid evolution with the growth of poetic and romantic feeling for nature, from Wilson and Gainsborough to Constable and Turner.

In this flourishing age of the later eighteenth century there was a good deal that Hogarth would have found uncongenial. The Royal Academy, the foundation of which he had opposed so tenaciously, was successfully launched. The regard for foreign and classic authority was as strong as ever, though better informed. The theories of Sir Joshua Reynolds, as set out in his *Discourses*, were of the classic kind, with a respectful bow to precedent alien to Hogarth's way of thinking. Nothing could be further from it than a precept such as this from the Sixth Discourse of 1774:

> From the remains of the works of the ancients the modern arts were revived and it is by their means that they must be restored a second time. However it may mortify our vanity, we must be forced to allow them our masters ...

It could be said of Hogarth, as it was said of another great independent, Paul Cézanne, that he was both famous and unknown. His death passed with little notice though his prints were hung

everywhere. The opinion long prevailed that he was negligible as a painter. Ready to praise his genius as 'a writer of comedy with a pencil', Walpole, never infallible in judgment, could airily assert that as a painter 'he had but slender merit'. Charles Lamb's famous essay, so excellent on Hogarth's subjects and characters, quoted with approval Coleridge's remark on the many beautiful female faces to be found in Hogarth's works, but had no word to say of the beauty of the paintings. It was not until the Hogarth exhibition at the British Institution in 1814 that they gained attention as distinct from the engravings.

William Hazlitt was then the first to comment on the harmony, gradations and delicacies of his colour as well as Hogarth's insight into human nature. John Constable, after him, with a fellow feeling for an artist who like himself had steered an original course, recognized in Hogarth a like understanding of his medium. Edmund Burke had said that Reynolds 'was the first Englishman who added the praise of the elegant arts to the other glories of his country'. With due respect to Reynolds, Constable in one of his lectures pointed out that Burke had forgotten 'Hogarth was born twenty-six years before Sir Joshua and had published his engravings of *A Harlot's Progress* when Reynolds was but eleven years old; or it may be that he was influenced by the common opinion of the time which we find echoed by Walpole, that Hogarth was *no painter*'. Constable's italics emphasized his astonishment that such a view could be possible. He added that 'Hogarth had no school nor has he ever been imitated with tolerable success', a dictum that might be qualified in some ways. Hogarth established the tradition of the conversation piece in its English form.

It is a reasonable inference that through the assembly of artists he helped to bring together in St Martin's Lane and the contributions to the Foundling Hospital for which he set the example, he promoted a sense of national identity in art that had previously been lacking. The engravings had their continued influence. In Thomas Rowlandson, who studied them, there is – leaving the element of caricature out of account – a parallel in the observation of and delight in the social scene. *Satan, Sin and Death*, that singular flash of allegory, made its impression on Fuseli and others towards the end of the century who found inspiration in Milton's themes as well as those of Shakespeare. Its celebrity prompted caricature in James Gillray's satirical print published in 1792, which showed

the Queen naked as 'Sin' intervening between Pitt, 'Death', wearing the usurper's royal crown and his enemy, the Lord Chancellor, Baron Thurlow, 'the Devil'. *A Rake's Progress* has never ceased to incite fresh interpretations from William Powell Frith's *Road to Ruin* to twentieth-century efforts to bring the theme up to date. One may think of Daumier's lawyers when looking at Hogarth's *The Bench*, or of Goya's prison and madhouse scenes in comparison with Hogarth's Newgate and Bedlam.

It was his unique achievement to portray the whole of his world: but with such other qualities of the great painter and composer as one so little inclined to respect for subject matter or national idiosyncrasy in art as James McNeill Whistler could recognize. 'They are fools,' said Whistler to a fellow artist in the 1890s, referring with a customary lack of amiability to Victorian England in general. 'They had a great painter in Hogarth – and they don't know it.' It was true that such a typical Victorian as Thackeray wrote of him as a humourist (a term that Hogarth himself viewed with suspicion). Whistler's remark has not lost its point in recalling how much more the work of one so essentially an artist contained.

Epilogue

The growth of London has not spared the homes of the great. Hogarth's house in Leicester Square has long since vanished from the scene, the sign of the Golden Head, the gilded likeness of Van Dyck that he carved out of cork and hung over his door long ago crumbled into dust. The last association of the building with the family was in 1790 when the 'Pictures and prints of the late Mr Hogarth' were sold at auction in Leicester Square. They realized no more than £255. It is recorded that 'a parcel of Academy figures and studies by Mr Hogarth' then fetched the trivial sum of eleven shillings and sixpence. Thereafter the house became one of the hotels catering for foreigners that flourished in the region, the Sablonnière, until it was pulled down in 1870 to make way for Archbishop Tenison's school.

On the opposite side of the square, the house of Sir Joshua Reynolds survived until the present century. His octagonal studio was for some time an auction-room, later, within living memory, the house was the scene of champion billiards matches until swallowed at last by the premises of the Automobile Association.

Chiswick has more mementoes of Hogarth and his family. They were all buried in St Nicholas's Churchyard, his mother-in-law, Sir James Thornhill's widow one of the household until her death in 1757 at the age of eighty-four, Hogarth himself, his sister Ann and finally his wife Jane. She, of whom we know so little save for what may be deduced of harmony and affection in a marriage that had lasted for thirty-five years, had still twenty-five years to live when he died in 1764. Their names are together on the monument that Garrick erected to Hogarth's memory in the churchyard, inscribed with the actor's well-meant verses (that Dr Johnson

criticized as giving their subject too little 'discriminative character') and carved with the appropriate symbols of brush, palette and book – the *Analysis of Beauty*.

Like the placid aftermath of controversy, in brick and Portland stone, the two houses so near together, Lord Burlington's Palladian villa and the Hogarths' 'little country box near the Thames', remain in lasting contrast and witness to the opposite aims and nature of their original owners. As might be expected, the Hogarths' choice was for an unpretentious dwelling, its plain façade in the Queen Anne style, broken only by the projecting Georgian bay window of the best parlour, with nicely proportioned rooms and a studio at the end of a walled garden. The building's unassuming charm has withstood the passing of time, though it was to go through many vicissitudes after Jane Hogarth died in 1789 at the age of eighty. After being occupied by her cousin, Mary Lewis, and then by the Rev. Henry Francis Carey, curate of Chiswick and translator of Dante, the house suffered from a long period of decay and neglect. The stable and painting room over it fell down in 1868. Such relics as Hogarth's armchair, made of cherry wood and padded with leather; the engraved stones let into the garden wall in memory of his pets, his bullfinch ('Alas! poor Dick'), one of that series of pugs so often appearing in his works ('life to the last enjoyed, here Pompey lies'), have disappeared along with much else. The house was an empty shell when restored in the early twentieth century and finally, with the addition of suitably period furniture and a set of Hogarth's prints, opened to the public as a Hogarth museum.

A reminder of Garrick's friendship remains in the leaden urns he gave to adorn the gateposts. The mulberry tree in the garden that provided mulberry tarts for the Foundling orphans whom Hogarth entertained and found homes for in Chiswick also survives. A sliver, polished to an abstract smoothness, is preserved inside the house in record of damage to the tree by a bomb in 1940. A waif from another world, surrounded now by offices and factories, assailed by the unceasing roar of traffic on the Great West Road, the house and garden within a high wall bravely preserve as much of the atmosphere of Hogarth's lifetime as now can be.

Lord Burlington's Chiswick House remains, a monument to the taste that Hogarth treated so lightly, an empty shell mainly, save

for the exuberant touches of decoration that Kent supplied. When Lord Burlington died in 1753 the estate became a property of the ducal Devonshire family through the marriage of Lord Hartington, later the fourth Duke of Devonshire, to the heiress of the Irish and English Burlington estates. It is difficult now to imagine that long period of social lustre it had under the auspices of Georgiana, Duchess of Devonshire and later. In the 1850s the works of art acquired by Burlington were suffering from neglect, according to the cataloguer of great collections, Gustav Friedrich Waagen, the author of *Treasures of Art in Great Britain*. His report was that 'among the pictures are many good and even excellent but that, unfortunately, they are partly in a bad condition, either from the want of cleaning or from dryness'. Their removal by the eighth Duke in 1892 to Chatsworth and elsewhere has left a certain vacuum but the house with little trace of human occupancy is still to be appreciated as a learned exposition of Palladian architecture. The grounds retain the picturesque surprises contrived by Kent and those of a following day. In what is now a public park the spectator may admire the artificial water spanned by the classic bridge James Wyatt added, the temple, symbol of classic memory, the Inigo Jones gateway that Burlington acquired from Sir Hans Sloane, the obelisk, the Doric column, the cascade that at once respected and harnessed Nature, the conservatory designed by Paxton, planner of the Great Exhibition's 'palace of glass'. The visitor here and in Hogarth Lane, if inclined to Johnsonian reflection, may ponder on the varied motives of the early eighteenth century and the nice proportioning of tribute due to its distinguished patron and architect, Burlington, and Hogarth its great rebel, at once the critic and the mighty historian of his age.

Bibliography

On Hogarth

Antal, Frederick, *Hogarth and His Place in European Art*, Routledge, 1962

Beckett, R. B., *Hogarth*, Routledge, 1949

Dobson, Austin, *William Hogarth*, new edition with bibliography of books, pamphlets etc. relating to Hogarth and his work, Heinemann, 1907

Hogarth, William, *The Analysis of Beauty*, with the rejected passages from the manuscript drafts and autobiographical notes. Edited with an Introduction by Joseph Burke, Oxford, 1955

Lichtenberg, G. C., *Commentaries on Hogarth's Engravings*, translated from the German and with an Introduction by Innes and Gustav Herdan, Cresset Press, 1966

Mitchell, Charles (Ed. with an Introduction), *Hogarth's Peregrination*, Oxford, 1952

Moore, Robert Etheridge, *Hogarth's Literary Relationships*, Oxford, 1948

Nichols, J. B. (Ed.), *Anecdotes of Hogarth, Written by Himself*, 1833. Facsimile with Introduction by R. W. Lightbown, Cornmarket Press, 1970

Oppé, A. P., *Drawings of William Hogarth*, Phaidon, 1948

Paulson, Ronald, *Hogarth's Graphic Works*, two volumes, Yale University Press, 1965, new edition, 1970

—— *Hogarth: His Life, Art and Times*, two volumes, Yale University Press, 1971

——*The Art of Hogarth*, Phaidon, 1975

Vertue, George, *Notebooks*, Walpole Society Publications, volumes of various dates

Walpole, Horace, *Anecdotes of Painting in England*, three volumes, Wornum Edition, 1876

Whitley, William T., *Artists and Their Friends in England, 1700–1799*, two volumes, Medici Society, 1925

For General Reference

Croft-Murray, E., *Decorative Painting in Britain*, Vol. II, Country Life, 1970

Edwards, Ralph, *Early Conversation Pictures*, Country Life, 1954

Levey, Michael, *Rococo to Revolution*, Thames and Hudson, 1966

Summerson, John, *Georgian London*, Barrie and Jenkins, 1970

Trevelyan, G. M., *English Social History*, Penguin, 1967

Catalogue of Political and Personal Satires, Vols. III and IV, British Library

Exhibition and Other Catalogues

Apollo of the Arts, Lord Burlington and his Circle, with essays on his contribution to architecture, painting and music, Nottingham University Art Gallery, 1973

The Conversation Piece in Georgian England, Iveagh Bequest, 1955

Thomas Coram Foundation for Children, Sir Alec Martin's catalogue of the Foundation's works of art, 1965

The Georgian Playhouse, Hayward Gallery, 1975

Hogarth, Lawrence Gowing and Ronald Paulson, Tate Gallery, 1971, admirably detailed and illustrated

Godfrey Kneller, Introduction by J. D. Stuart, National Portrait Gallery, 1971

Allan Ramsay, Introduction by Alistair Smart, Royal Academy, 1964

Samuel Scott, bicentenary, Guildhall Art Gallery, 1972

Exhibitions

Those throwing fresh light on artists in Hogarth's time at the Iveagh Bequest, Kenwood, include:

Francis Hayman, 1960

Joseph Highmore, 1963

Philip Mercier (also at the City Art Gallery, York), 1969

George Lambert, 1970

Index

The dates of the more important of Hogarth's contemporaries are given